HELEN SAUNDERS
MODERNIST REBEL

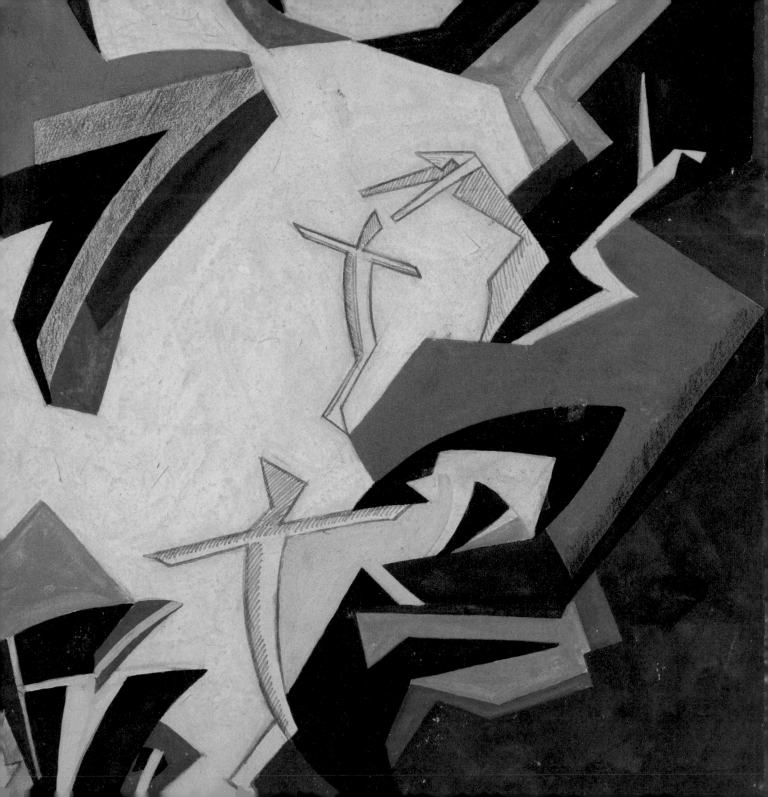

HELEN SAUNDERS
MODERNIST REBEL

Edited by
Rachel Sloan

The Courtauld

First published to accompany the exhibition

HELEN SAUNDERS
MODERNIST REBEL

The Courtauld Gallery, London
14 October 2022 – 29 January 2023

The programme of the Gilbert and Ildiko Butler
Drawings Gallery at The Courtauld is supported by
the International Music & Art Foundation

The Courtauld Gallery is supported by Research England

ISBN 978-1-913645-31-1
ebook 978-1-914532-12-2

British Library Catalogue in Publishing Data

A CIP record of this publication is available from the
British Library

Produced by Paul Holberton Publishing, London
paulholberton.com

Designed by Laura Parker
Printed by Gomer Press, Llandysul

Front cover: detail of cat. 13; back cover: detail of cat. 14;
frontispiece: detail of cat. 12

Contents

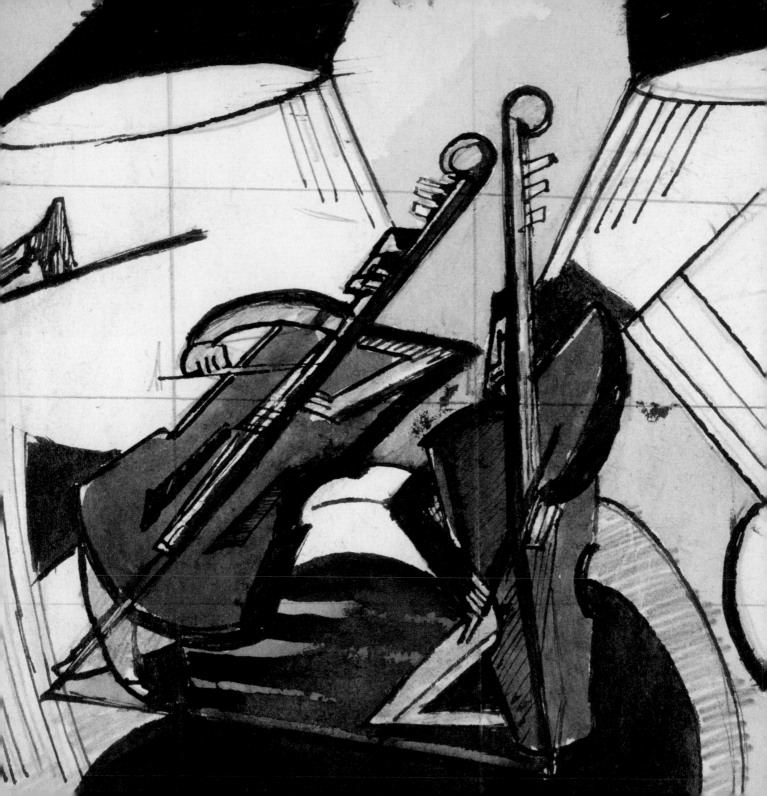

Foreword

Ernst Vegelin van Claerbergen
Head of The Courtauld Gallery

In 2016 The Courtauld received the magnificent gift of 20 drawings and watercolours by Helen Saunders (1885–1963). They were presented by Brigid Peppin, a relation of the artist and a noted scholar of her work. It is the largest group of works by Saunders in any public collection and forms an essential reference point for the study of this pioneering female artist. The Courtauld is delighted to present these works for the first time in a dedicated exhibition.

Helen Saunders's reputation rests to a large extent on her membership of the radical Vorticist group of artists and writers. She was one of two female signatories of the Vorticist manifesto in 1914; she exhibited with the group and she contributed to its publication, *BLAST*. The works that she made during this short period are extraordinarily powerful and original. They show a sophisticated understanding of the language of hard-edged abstraction, applied to the creation of images of immense daring and dynamism. The exhibition has at its heart a powerful sequence of these rare and important Vorticist works on paper. It also includes a wonderful group of highly inventive earlier compositions and extends beyond Vorticism into the 1920s, thereby offering a wider introduction to Saunders's art.

Helen Saunders's work was unrecognised after the First World War, and decades of critical obscurity followed her death in 1963. The revival of her reputation is almost entirely due to Brigid Peppin, who, in 1996, curated the first monographic show on the artist and who has contributed to many projects since then. Saunders's inclusion in the major exhibition on women and abstraction at the Centre Pompidou in Paris in 2021 confirms her full return to critical attention.

The Courtauld is deeply grateful to Brigid Peppin for her gift, which entrusts us with an important role in the study and public enjoyment of Saunders's work. We also thank her for her invaluable contribution to this catalogue. Our warm thanks go to Jo Cottrell of Birkbeck, University of London for her illuminating and scholarly essay. The exhibition has been curated by Rachel Sloan, the Gallery's Assistant Curator of Works on Paper. I am most grateful to her for her care and professionalism. Finally, I record my gratitude to the International Music and Art Foundation and to James Bartos for their generous ongoing support of our series of exhibitions and displays dedicated to exploring aspects of the history of drawing.

This exhibition is accompanied by a special display arising from a collaboration between The Courtauld's History of Art and Conservation departments entitled *A Modern Masterpiece Uncovered: Wyndham Lewis, Helen Saunders and 'Praxitella'*. We are very grateful to its curators, Courtauld alumnae Rebecca Chipkin and Helen Kohn, and to Leeds Art Gallery for their important loan to this project.

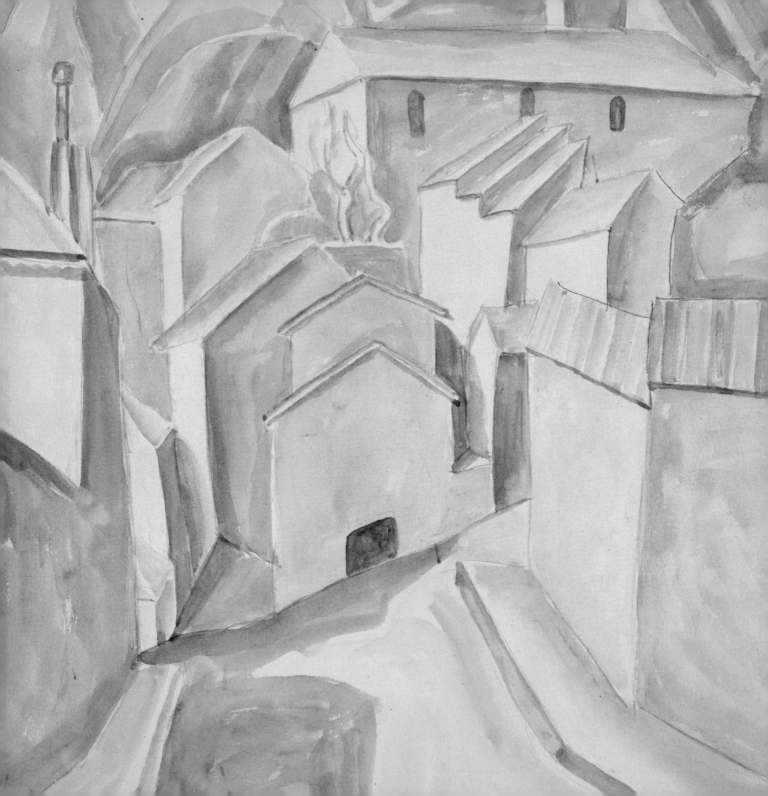

Helen Saunders (1885–1963): Mapping a career

Brigid Peppin

[handwritten annotation: correlative, gave works to Courtauld, responsible for HS attention]

Helen Saunders (her family pronounced their surname 'Sarnders' rather than the more generally used 'Sawnders') was one of the two women artists who participated in Vorticism, the British avant-garde art movement spearheaded by Wyndham Lewis (1882–1957). Distancing itself from Cubism in France and Futurism in Italy, Vorticism set out to celebrate the essential character of modern urban and industrial life. But the summer of 1914, less than two months before the outbreak of World War I, was an inauspicious moment to launch a new art movement; in the event, Vorticist ideas did not gain widespread recognition and the number of works produced by the group's members was relatively small. The movement's eclipse was mirrored in Saunders's career. Between 1912 and 1916 she was at the forefront of modernist painting in Britain, but thereafter her work was rarely shown. Her artistic trajectory was first traced in a retrospective exhibition at the Ashmolean Museum in 1996.[1] The Courtauld's more focused display shows her development from her pre-Vorticist period, when she exhibited under the aegis of Roger Fry (1866–1934), through Vorticism, to her less radical but nevertheless intensely serious later watercolours. This essay attempts to frame these works by considering some aspects of her life and practice.

Asked in old age about her art training, Saunders recalled that she studied at the Slade School of Fine Art and later attended classes at the Central School of Arts and Crafts.[2] In reality her principal art studies (1903–06) were at the teaching studio for women set up in Ealing, West London, by the 21-year-old Slade-trained Rosa Waugh (1882–1971).[3] Waugh's curriculum was based on that of the Slade, and the studio was staffed by Slade-trained artists, including Waugh's friend Katie Gliddon (1883–1967). Gliddon and Waugh were both later imprisoned for their political actions – Gliddon while campaigning for women's suffrage and Waugh while promoting pacifism during World War I; Saunders remained close friends with both.[4] Other tutors were Gwen Salmond (1877–1958) and Albert Rutherston (1881–1953).[5] Augustus John (1878–1961) was enlisted to give Saunders a one-to-one portrait painting demonstration.[6]

Waugh had a particular interest in spatial representation, and developed an empirical approach which she called 'Natural Perspective', arguing that 'a wandering field of vision' – the everyday experience of circular, overlapping and shifting visual fields – was more relevant to the experience of seeing than the fixed vanishing-point of the traditional Albertian system taught in schools. 'Natural Perspective' explored changes in shape and outline produced by motion on the part of the spectator or the object being viewed, and the disparities of scale caused by relative nearness and distance.[7] But, perhaps surprisingly, Waugh does not seem to have connected these ideas with the radical re-workings of pictorial space that were being developed by avant-garde painters in Paris and elsewhere.

1 Helen Saunders, c. 1916
(photograph: Frederick Etchells)

Detail of cat. 15

2 Litlington (photograph, 1995)

3 Helen Saunders, *Litlington*, c 1911–12, oil on canvas, 50.5 × 61 cm. Private collection

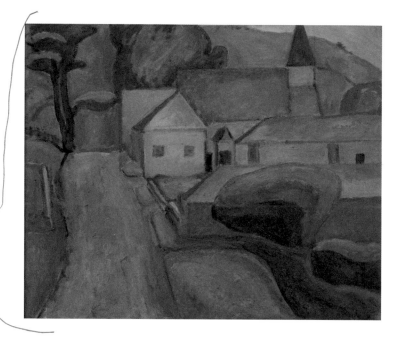

1/2 pre-vorticist oils not survived

For Saunders, 'Natural Perspective' provided a stepping-stone towards spatial re-thinking. In the landscape currently known as *Litlington* (fig. 3),[8] one of only two pre-Vorticist oils by her to survive, she incorporated several viewpoints. Her translation of the gentle uphill slope of the road into an almost vertical slab, her adoption of an elevated viewpoint and her inclusion of distant hills invisible from ground level recall the vertical arc that Waugh identifies in her analysis of visual exploration.

If the three years Saunders had spent studying with Waugh laid the foundations for her artistic practice, the classes that she later took at the Central School probably extended her connections within avant-garde circles. The Central's records were lost in World War II, but tutors there included Bernard Adeney (1878–1966), who exhibited with the Vorticists in 1915, and the printmaker Noel Rooke (1881–1953), formerly a close friend of Waugh. Rooke's course in 'Black and White Drawing for Reproduction' was co-taught in 1909–10 by Frederick Etchells (1886–1973), soon to be a protégé of Roger Fry and afterwards a member of the Vorticist group.[9] The likelihood that Saunders enrolled on this course is supported by a comment by the Bloomsbury art critic Clive Bell. In a review of the Allied Artists' Association exhibition of 1912, Bell suggested that Saunders's three contributions (all now lost) 'were painted surely under the influence of

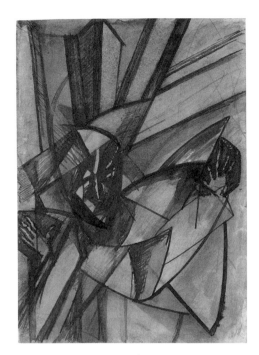

4 Wyndham Lewis, *Futurist figure*, c. 1912, graphite, pen and ink, ink wash and wash on paper, 260 × 185 mm. Private collection (ex collection David Bowie, sold Sotheby's, 10 November 2016)

HS starts to participate in shows

portrait of HS

Mr. Etchells'.[10] At that time Etchells was working in what Frances Spalding has described as a 'Byzantine' manner, seen in his Borough Polytechnic mural (1911) and to a lesser extent in paintings like *The Dead Mole* and *The Entry into Jerusalem* (c. 1912).[11] Bell's comment, reflecting the then established view that women artists normally worked under the influence of their male counterparts, was perhaps prompted by prior knowledge of a friendship between Etchells and Saunders. None of Saunders's extant paintings resemble Etchells's 1911–12 work, so Bell's observation also raises the intriguing possibility of a hitherto unknown phase in her development.[12]

In around 1911 Saunders moved away from her parents' large, comfortable home in Ealing into rented rooms in a terraced house, 4 Phene St, in Chelsea;[13] in an undated letter to Gliddon, Waugh noted the 'primitive arrangements' there.[14] She was already alert to the ground-breaking ideas heralded in Roger Fry's seminal exhibition 'Manet and the Post-Impressionists' (Grafton Galleries, 1910–11),[15] while a further exhibition, 'Paul Cézanne and Paul Gauguin' (Stafford Gallery, 1911) positioned these artists as the founders of Post-Impressionism.[16] In 1912 she started to exhibit with London's avant-garde; in February her painting *Rocks, North Devon* (lost) was shown at the Friday Club, the exhibiting group founded by Vanessa Bell; in May, she was included in 'Quelques Independents Anglais', a show curated by Roger Fry at the Galerie Barbazanges in Paris, and in July she contributed three paintings to the 5th Allied Artists' Association London Salon.

In March 1913, Fry invited her to contribute to the 1st Grafton Group Exhibition at the Alpine Club Gallery.[17] In cataloguing this show, Fry wrote: 'It has been thought interesting to try the experiment of exhibiting the pictures anonymously in order to invite the spectator to gain at least a first impression of the several works without the slight and almost unconscious predilection which a name generally arouses'.[18] Part of Fry's purpose in concealing the authorship of individual works may have been to counter the prevailing prejudice against women artists. Saunders's *Litlington* (fig. 3) can now be identified with reasonable confidence as *Barn and Road* (cat. 12 in Fry's show), since the roadside buildings are agricultural; the painting retains, unusually, an original frame, indicating that it was exhibited. Saunders continued to experiment with new ideas: in July 1913 her painting *The Oast House* (lost), in the 6th Allied Artists' Association London Salon, was described as 'Cubist' by a visitor to the show,[19] and studies showing her engagement with Cubism are included in the present exhibition.

Saunders was friends with Wyndham Lewis by 1912; his drawing currently known as *Futurist figure* (fig. 4) is undoubtedly a portrait of her (see fig. 1).[20] It is one of the earliest works in which he combined

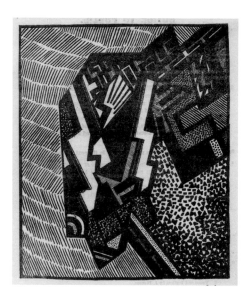

5 Helen Saunders, *Island of Laputa*, 1915, black and white line block reproduction, 180 × 150 mm, in *BLAST 2*, July 1915, p. 8

portraiture with 'cubist/futurist' geometry, probably spurred by the fact that its subject was an artist who was already exploring cutting-edge visual language in her own work. Among his six known portraits of Saunders, this one most perceptively captures her open-eyed exploration of unknown territory.[21]

Since Saunders did not participate in Fry's Omega Workshops, which opened in June 1913, she was not part of the acrimonious exodus of Etchells, Cuthbert Hamilton, Edward Wadsworth and Wyndham Lewis four months later. However, she was closely involved with the Rebel Art Centre (April–July 1914), initiated by Lewis and intended as a focus for radical artistic and literary innovation. Retrospectively comparing Omega to the Rebel Art Centre, Saunders recorded that the latter placed 'perhaps more emphasis on formal design and "abstract" painting'.[22] Though short-lived, the Rebel Art Centre served as the launch-pad for Vorticism. The movement's title, coined by the American poet Ezra Pound (1885–1972) from the word 'vortex', simultaneously indicated the point of maximum energy within a whirlpool and its still centre. The provocative Vorticist Manifesto, mainly written by Lewis, appeared in the first issue of the movement's periodical *BLAST* (June 1914), published from the Rebel Art Centre. It proclaimed that since England had invented the industrial revolution, Vorticist art must embody, rather than merely imitate, the bareness, hardness and dynamism of modern cities and machinery.[23]

Saunders and her colleague Jessica Dismorr (1885–1939) were the only women among the eleven signatories of the manifesto.[24] As with Fry's curating experiment at the Grafton Gallery (though probably for a different reason), the gender of Vorticist adherents was concealed; surnames and initials, but not forenames, were listed and Saunders's surname was deliberately misspelt.[25] Neither Saunders nor Dismorr contributed drawings or written pieces to *BLAST*'s first issue,[26] but the second, 'War Number' (July 1915), distributed from Saunders's Phene Street lodgings, contained drawn and written contributions from both. The two drawings by Saunders reproduced in *BLAST 2* were *Island of Laputa* (fig. 5)[27] and *Atlantic City* (fig. 6).[28] Etchells later claimed to have suggested the title of *Island of Laputa* after it was completed, referencing the floating island in Jonathan Swift's *Gulliver's Travels* (1726).[29] The inhabitants of Laputa spent their time studying mathematics, astronomy and music, but were incapable of applying these disciplines to any practical end. Etchells's title suggests a reading of Saunders's image as a head in profile stuffed with geometrical ideas, and so a metaphor for Vorticist artistic practice.[30]

In contrast to *Island of Laputa,* the subject of *Atlantic City* was contemporary and topical. This resort town in New Jersey underwent spectacular expansion in the early twentieth century, and became internationally known for its seven-mile beach-side boardwalk and for

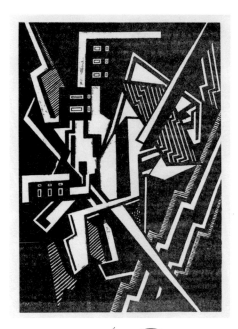

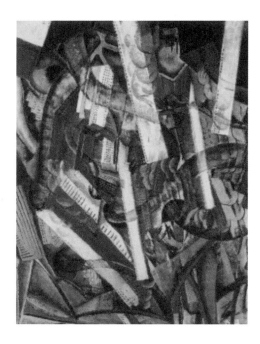

6 Helen Saunders, *Atlantic City*, 1915, black and white line block reproduction, 153 × 105 mm, in *BLAST* 2, July 1915, p. 57

7 Max Weber, *New York*, 1913, oil on canvas, 101 × 81.3 cm. Private collection

its vast and luxurious hotels, the most extravagant of which, the sixteen-storey Traymore, was completed early in 1915. In Saunders's drawing, an explosive composition is formed from fragmented references to the boardwalk, coastline and hotel buildings. Its raised viewpoint and dynamic composition may have gained inspiration from the painting *New York* (fig. 7) by the American painter Max Weber (1881–1961), who had been the principal exhibitor in Roger Fry's 1913 Grafton Group exhibition.[31] *New York* was the most radical of the eleven works that Weber had shown there, and Saunders, an invited participant in the exhibition, would certainly have seen it.[32] The black and white version of *Atlantic City* in BLAST has recently been linked by Rebecca Chipkin and Helen Kohn to an ambitious polychrome oil painting discovered beneath Wyndham Lewis's *Praxitella*, a large portrait dating from 1920, and it seems certain that this obliterated work is one of the four paintings, all previously thought lost, that Saunders showed at the Vorticist Exhibition at the Doré Galleries in June 1915.[33]

Another drawing, now known as *Monochrome abstract composition*, c. 1915, in ink and wash (fig. 8), may initially have been intended for *BLAST*, the first issue of which contained half-tone reproductions of artworks. In the event, the second issue contained almost only line-block drawings,

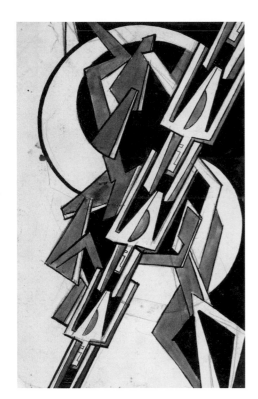

8 Helen Saunders, *Monochrome abstract composition*, c. 1915, ink, watercolour and graphite on paper, 289 × 184 mm. Tate, T00622

highlight cttds
basrd Wu I

in black and white, probably for reasons of cost.[34] Saunders's unsigned drawing, the subject perhaps prompted by the unfolding catastrophe of World War I, was unframed when Ethel Saunders presented it to the Tate in 1963, so its orientation remains uncertain; is the column of figures rising upwards or plunging downwards?[35] This ambiguity was possibly intentional, highlighting the then conflicting attitudes towards the war. Saunders's awareness of these debates would have been sharpened by her artist cousin Reynolds Ball (1882–1918), a conscientious objector who early in the war joined a Quaker ambulance mission to France,[36] and by her pacifist friend Rosa Waugh (later Hobhouse).[37]

Saunders's Imagist poem 'Vision of Mud', published in *BLAST 2*, visualising suffocation and death in the deep mud of the World War I trenches, again reflects these oppositional stances.[38] It contrasts soldiers' misery in the trenches with the fanfare of the recruiting band ('The drums thud and the fifes pipe on tip-toe'), and the view, widespread in 1915, of the purifying effect of war ('Such mud, naturally, is medicinal It is a health-resort').[39] The sense of mindless entitlement shown by Saunders's imaginary combatants ('I am too proud and too lazy: So I turn over and think of my ancestors') precedes the moment when they, like all their forebears, are subsumed into nature ('Rain falls in the grave distance You smell weak moss, brown earth. The wind blows gently').

On 2 November 1914, Ezra Pound's 'Preliminary Announcement of the College of Arts' was published in *The Egoist*. This scheme, aimed principally at Americans planning to study in Europe, consisted of a range of 'Ateliers' grouped into schools. The 'Atelier of Painting' was to be headed by Wyndham Lewis, with Saunders (again appearing as 'H. Sanders') as 'Assistant, and Director of the Atelier'; Gaudier-Brzeska and Wadsworth were to be in charge of the Ateliers of Sculpture and Design respectively.[40] Perhaps thanks to the war, the college remained a pipe dream. But Saunders was well represented in the two Vorticist exhibitions, the first of which, at London's Doré Galleries (June 1915), showed six of her works – two drawings and four paintings, including *Atlantic City*; Dismorr showed four paintings.[41] The second, curated by Ezra Pound and the American lawyer and collector John Quinn[42] at the Penguin Club in New York (January 1917), included four drawings by Saunders. Dismorr contributed four paintings and a painting and three drawings respectively to these exhibitions.

In late 1915, Lewis and Saunders embarked on an ambitious decorative project, known as the 'Vorticist Room', at the Restaurant de la Tour Eiffel in Percy St, London W1. The extent and nature of Saunders's contribution have been a matter of debate. While Richard Cork speculated that her role 'was probably limited to the faithful execution of [Lewis's] instructions',[43] Jo Cottrell has persuasively argued that Saunders played a

L+S – vrtzist rm @ restsrnt – pedrad to L ony

9 Helen Saunders, *Dance*, c. 1915, graphite and bodycolour on paper, 375 × 292 mm. The David and Alfred Smart Museum of Art, the University of Chicago, 2009.34

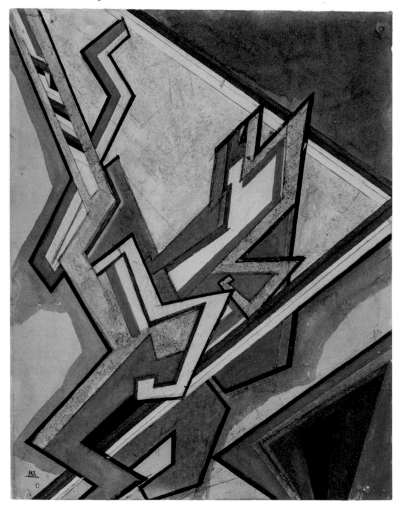

1914-16 - HS produced lots of vorticist works

much more significant creative role.[44] Between c. 1914 and 1916 Saunders produced a substantial body of Vorticist paintings and drawings,[45] and Lewis may well have appreciated that her imagery was as varied as his own, and her use of colour more inventive and daring. Nevertheless, when the 'Vorticist Room' was unveiled, it was credited to Lewis alone.[46] Saunders was well aware of Lewis's need to remain in the public eye due to his always precarious finances, so was probably content for her participation to remain unacknowledged.[47]

↳ women not credited - was OK but unacknowledged

Three finished compositions, *Canon, Dance* (fig. 9) and *Balance* (fig. 10), contributed by Saunders to the Vorticist exhibition in New York, were rediscovered in Chicago in 2009.[48] Unlike her other surviving Vorticist works, these signed gouaches have secure titles.[49] They show Saunders's adaptation of the dynamic geometry of Vorticism to explore emotion and experience. *Dance* (fig. 9), for example, evokes the 'wiggles, contortions, romping, flounces' of new popular dances like 'Grizzly Bear' and 'Turkey Trot',[50] as well as the radically experimental Ballets Russes.[51] The theme of dance, already widespread in French art, inspired other artists in the Vorticist circle – Laurence Atkinson, David Bomberg, Henri Gaudier-Brzeska, William Roberts and Lewis himself – but Saunders's composition is uniquely successful in capturing the convention-shattering body movements characteristic of these new forms. In *Balance* (fig. 10), two jousting figures, teetering precariously, serve as a visual metaphor for the war as well as for the risks that Saunders was taking in her own work. These compositions endorse her later observation that 'shapes and their relationships have a "meaning" of their own apart from any literary or representational overtones'.[52]

A review by Edward Wadsworth of Vassily Kandinsky's *On the Spiritual in Art* was published in *BLAST 1*, and Kandinsky's insistence on 'the value of one's feelings as the only aesthetic impulse' clearly resonated with Saunders.[53] If she was responding to Kandinsky's assertion that 'bright colours vibrate more strongly in pointed, angular forms',[54] the liveliness of *Dance* and *Balance* offer confirmation of this idea.

These rediscovered works challenge entrenched views of Lewis's work as the Vorticist paradigm,[55] attesting to Saunders's independently creative mind and supporting her later statement that 'We all I think worked out our own ideas without thinking much of labels'.[56] She implicitly separated the written content of *BLAST* from the wider project of Vorticism, writing to Walter Michel: 'You are I am sure right in thinking that Lewis was to all intents and purposes Blast', and recalled that Lewis 'carried the rest of the team with him, some from conviction and some no doubt for their own purposes of advertisement'.[57] It is clear that Saunders was one of the 'team' members who embraced Vorticism's artistic aims from conviction – Vorticism was a cause to which she committed wholeheartedly.[58] Self-promotion was never part of her mind-set.

Saunders's relationship with Lewis has been the subject of speculation.[59] While employed in a government office during World War I, she acted as his secretary while he was in the army, renting rooms for him, moving his possessions and forwarding him the keys, typing his manuscripts, and mounting drawings he sent from the front. They were undoubtedly very close; undated letters from her, preserved by Lewis, show her passionate attachment,[60] but the risks of conception and

10 Helen Saunders, *Balance*, c. 1915, graphite and bodycolour on paper, 368 × 298 mm. The David and Alfred Smart Museum of Art, the University of Chicago, 2009.32

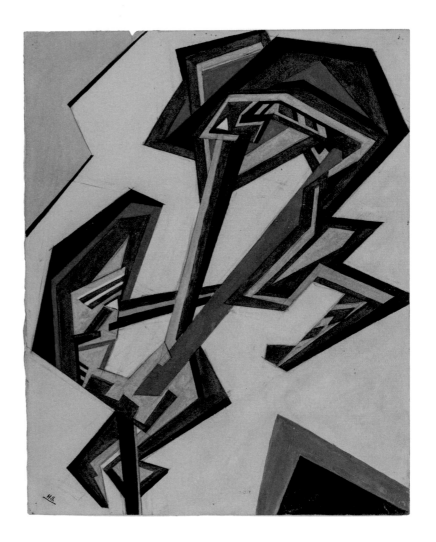

venereal disease (Lewis had had two children by his former lover Olive Johnson and was ill with gonorrhoea for an extended period in 1914–15) may have made her cautious of physical intimacy with him.[61] Perhaps significantly, Lewis referred to her, and addressed her in letters, as 'Miss Saunders' or 'Miss S', in contrast to his use of first names, or nicknames, in his interactions with women with whom he is known to have had affairs. It seems likely, given Lewis's history of turning against friends and supporters, that in spring 1919 he distanced himself from her in a

gratuitously hurtful way.[62] Following their estrangement she experienced an extreme emotional crisis.[63]

World War I brought Vorticism to an end. Lewis was later to write: 'The war was a sleep, deep and animal, in which I was visited by images of an order very new to me. Upon waking I found an altered world; and I had changed, too, very much. The geometrics that had interested me so exclusively before, I now felt were bleak and empty. They wanted *filling*.'[64] Anticipating a similar change in artistic direction, Saunders had already written to Dismorr in late 1917: 'I should very much like the chance of doing some quite representative painting – as literal as Van Gogh – and perhaps inventing something'.[65] She did not again return to abstraction.

From 1920 onwards, Saunders avoided group affiliation. Her personal reticence, home education, and the supportive milieu of Rosa Waugh's teaching studio left her ill-equipped to contend for recognition within the male-dominated and highly competitive art world, and her independent income protected her from the need for doing so. As she had explained to Dismorr, 'I am still a solitary by nature – and I still find it difficult to get much out of actual things except retrospectively and imaginatively – what I fear more than anything else is the monotonous stampede of other people's thoughts through my mind when my own thoughts are too tired or dissipated to give battle to the invaders'.[66] The Post-Impressionists she admired – Cézanne, Van Gogh and Gauguin – had each developed a strikingly original voice while distanced from the Parisian art world, and perhaps inspired by their example she embraced the prospect of working independently.[67]

The downside of her self-imposed isolation was, inevitably, artistic marginalisation.[68] But while rejecting professional groupings, Saunders maintained friendships with sympathetic artists.[69] In c. 1922 she became close to Walter Sickert, though she was to decline his offer of marriage.[70] She also remained friends with Jessica Dismorr, whose post-Vorticist career followed a very different trajectory from her own. Dismorr's work developed in distinct phases: early 'Fauve' landscapes, then Vorticist compositions, were followed in turn by watercolour landscapes, portraits, and a final return to abstraction during the 1930s.[71] At each stage she produced a body of finished, exhibitable works. No such sequential 'periods' are found in Saunders's later oeuvre; instead, she seems to have moved freely between landscape, portrait and still life, using each genre to explore a variety of pictorial challenges. It is often uncertain whether surviving paintings were intended as studies or as finished compositions – a distinction that in any case seems to have held little interest for her. She evidently thought of painting as a continuing exploration of ways in which she could truthfully respond to the visual world; a personal journey of discovery, spurred (to quote Kandinsky) by 'inner necessity'.

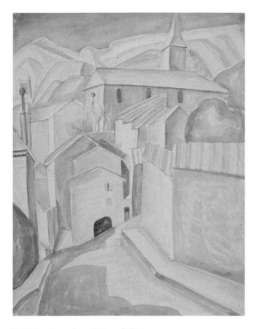

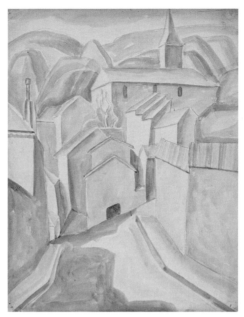

11 Helen Saunders, *View of L'Estaque*, c. 1923–26, graphite and watercolour on paper, 365 × 277 mm. Ashmolean Museum, Oxford, WA1997.41

12 Helen Saunders, *View of L'Estaque*, c. 1920–29, graphite and watercolour on paper, 383 × 296 mm. The Courtauld, London (Samuel Courtauld Trust), D.2016.XX.21 (cat. 15)

Both Saunders and Dismorr painted at L'Estaque in the south of France and at Port Isaac in Cornwall in the 1920s, though it is unclear whether they did so together or separately.[72] Their shared focus on the underlying structure of landscape reflected their earlier experiments with the geometrical language of Vorticism. Saunders's decision to visit L'Estaque in the early 1920s would have been prompted by Cézanne's long association with the town,[73] and by the proto-Cubist landscapes painted there by her close contemporary Georges Braque in 1907–09.[74] In her watercolours of this semi-industrialised Marseille suburb, she explored ways of reconciling geometrical abstraction with topographical fidelity, sometimes working on several versions of the same motif, adjusting and simplifying the forms while investigating their compositional and expressive possibilities. A comparison of two graphite and watercolour drawings made from the same viewpoint at a similar time of day (figs. 11 and 12) reveals small but significant differences that show her sensitivity to the cumulative effect of very minor changes in colour, tone and outline.[75]

While remaining in touch with recent developments, Saunders valued earlier achievements in European painting, and in 1960 she visited the major exhibition of paintings by Nicolas Poussin (1594–1665) at the Louvre. At first glance Poussin's figure compositions might seem an unlikely

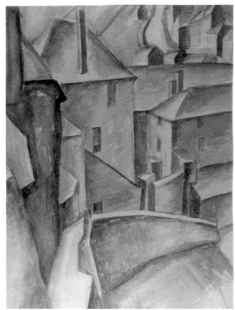

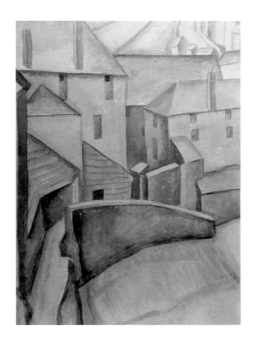

13 Helen Saunders, _Port Isaac Harbour_, c.1920s, graphite and watercolour on paper, 350 × 250 mm. Private collection

14 Helen Saunders, _Port Isaac Harbour_, c.1920s, graphite and watercolour on paper, 385 × 280 mm. Private collection

subject for her admiration. However, positioning Poussin as a precursor of Cézanne and Gauguin was by then a well-established trope. In a series of influential articles published together as _Théories_ (1909) the artist Maurice Denis (1870–1943) had identified Cézanne as 'the Poussin of Impressionism',[76] and Clive Bell, though arguing in 1914 that European art had followed a downward trajectory from Giotto to Cézanne, nevertheless described Poussin as 'the greatest artist of the age'.[77] The connection between Poussin and Cézanne was re-affirmed by Germain Bazin, principal curator at the Louvre at the time of the 1960 Poussin exhibition,[78] and Saunders's regard for Cézanne may have prompted her pilgrimage to the show. In any case she was probably drawn towards an artist whose work was known for 'appealing to the mind' and for 'expressive understatement'.[79] Poussin's cerebral approach to composition and perspective, and his frequent referencing of the picture plane in his depiction of spatial recession, would have resonated with similar concerns in her own practice.

In Saunders's watercolours of Port Isaac in Cornwall, where she painted repeatedly, she continued to explore ways of reconciling geometrical structure with the particularities of a locale. In 'Natural Perspective' Waugh had discussed the visual differences effected by small shifts in viewpoint, and Saunders pursued this investigation in

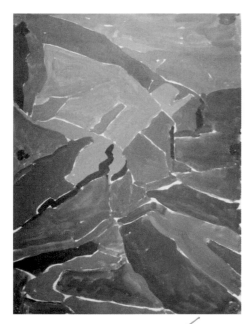

watercolours of Port Isaac Harbour (figs. 13 and 14), painted from slightly different positions on the harbour wall.

Some thirty years later her continuing interest in reconciling spatial recession with abstract patterning is evident in a series of gouache paintings of cliffs at St David's, Pembrokeshire (fig. 15). Here she used the unpainted paper support to outline the forms, giving emphasis to the picture surface.

Many of Saunders's still lifes show the geometrical underpinning also found in Poussin and Cézanne. Like Cézanne and afterwards Braque, she painted a repertory of everyday objects – books, newspapers, ceramics and fruit.[80] As with *Port Isaac Harbour*, the two versions of *Still life with milk bottle and pears* (fig. 16 and 17) show her continuing fascination with the significant pictorial impact of minor changes in viewing position.

In *Still life with vase* (fig. 18), the unpainted hardboard support became a key compositional element, producing, as with unpainted paper in *St David's Cliffs*, a tension between the picture space and the picture's surface. Her technique varied, ranging from flattened, almost hard-edged patterning to the looser, more expressionist treatment seen in *Still life* (fig. 19).

15 Helen Saunders, *St David's Cliffs*, c. 1950s graphite and bodycolour on paper, 380 × 285 mm. Private collection

16 Helen Saunders, *Still life with milk bottle and pears*, 1950s, graphite and bodycolour on paper, 380 × 285 mm. Private collection

17 Helen Saunders, *Still life with milk bottle and pears*, 1950s, graphite and bodycolour on paper, 355 × 250 mm. Private collection

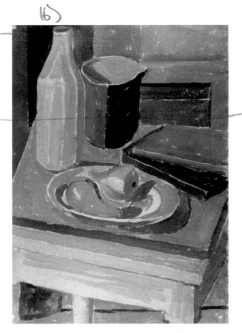

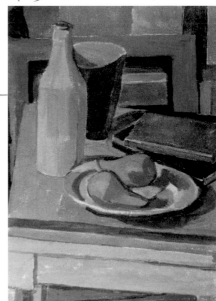

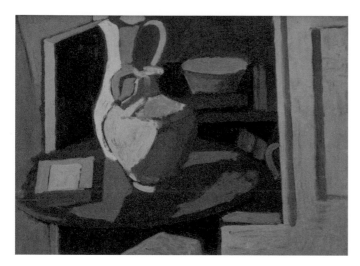

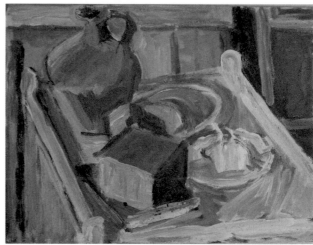

18 Helen Saunders, *Still life with vase*, 1950s, oil on hardboard, 40 × 55 cm. Private collection

19 Helen Saunders, *Still life*, 1950s, oil on Daler board, 35 × 47 cm. Private collection

20 Helen Saunders, *El Greco*, after 1938, oil on canvas, 61.5 × 51 cm. Private collection

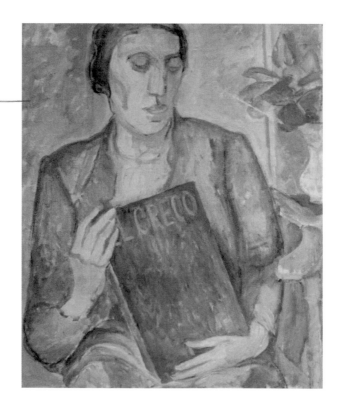

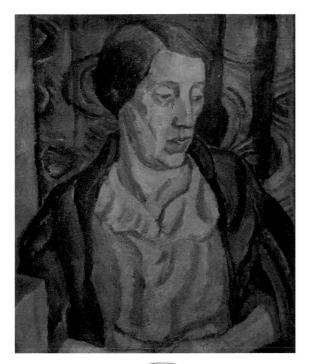

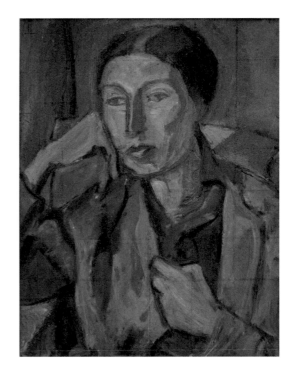

21 Helen Saunders, *Red curtain*, c. 1940s, oil on canvas, 60 × 51 cm. Private collection

22 Helen Saunders, *Portrait study*, c. 1950s, oil on board, 45 × 35 cm. Private collection

A portrait study by Saunders, now known as *El Greco* (fig. 20) suggests an alternative source for her more freely painted work. The sitter holds the copy of a 1938 Phaidon publication devoted to *El Greco* which Saunders owned,[81] and some of her portraits show distinct affinities with that artist's work.[82] If Poussin's classic geometry appealed to Saunders's quest for austerity and discipline, El Greco's intensity may have resonated with her pursuit of emotional expression. These opposite strands re-surface throughout her work, separately or in combination, from pre-Vorticist drawings like *Canal* and *Hammock* (see cat. 2 and 6) onwards. The dichotomy is clearly illustrated when *Still life with vase* and *Still life*, both dating from the 1950s and featuring the same terracotta urn, are seen side by side.

Several of Saunders's portraits invite comparison with those of Dismorr. The latter's portraits, usually in oil on gesso board and mainly dating from 1929–34,[83] were simplified and occasionally faux-naïve, showing greater interest in pose and composition than in facial detail. Saunders, too, sometimes took portraiture as a starting-point for formalised or schematic treatments. Her most frequent sitter was

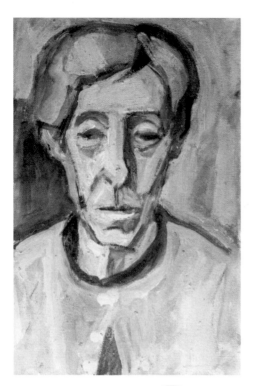

23 Helen Saunders, *Self-portrait*, c. 1950s, oil on hardboard, 40.5 × 25.5 cm. Private collection

Blanche Caudwell (1880–1950), a longstanding friend who was evidently happy to be the subject of experiment.[84] Caudwell's distinctive facial features, willingness to pose and apparent absence of vanity made her an ideal testing-site for compositional and iconographic ideas and paint application techniques. Many of these works, including *El Greco*, appear unfinished. At other times, in paintings like *Red curtain*[85] and *Portrait study*,[86] Saunders's approach was more naturalistic, recalling, perhaps, the demonstration given by Augustus John in Waugh's studio. Her occasional self-portraits culminated in a late series in oil (fig. 23), in which she recorded the effects of ageing, seemingly confronting her own mortality.[87]

In December 1962, Saunders reflected on her life and circumstances in a long letter to Rosa Waugh Hobhouse:[88]

> The only place where that word ['discouragement'] seems to be appropriate is that I am 'discouraged' when I send pictures to Shows and they are rejected. But I have guarded against that 'cold water' for several years now by only sending to the two annual shows in Holborn – and these have always taken 2 or 3 or sometimes 4 (the limit) of the works I have sent them[89]
> I feel myself that I have had some of the best luck in the world and some perhaps of the worst! But NO – other people have had far worse misfortunes.
> My present way of life suits the person I am very well and I take considerable pleasure in my rooms and my view and am very relieved at the notion I shall almost certainly be able to stay on here as long as my eyes and health make it possible for me to be on my own
> I don't really paint 'in order to keep well', but rather try to keep well 'in order to paint'.

Saunders died in her rooms on the top floor of 39 Grays Inn Road.[90] On the exceptionally cold morning of 1 January 1963 she probably turned on the gas fire, then retreated to bed while the room warmed; reduced gas pressure likely caused the flame to cut out. A fellow-tenant at the address wrote: 'when I found Helen Saunders I thought for a moment that she was just asleep. She looked so beautiful and happy and completely at ease We all loved her very dearly'.[91]

1 Peppin 2016.

2 Saunders 1956. The Slade's records show that she attended, part-time, for a term (January–March 1907). She later told a relative, Helen Peppin, that she had gained little from her brief time there.

3 Waugh's teaching studio was small, single-sex, relatively short-lived (c. 1903–09) and was forgotten by the 1950s.

4 Waugh spent three months in Northampton Gaol in 1916. Gliddon joined the 1908 NUWSS procession to the Albert Hall, carrying 'her palette and a large bunch of rhododendrons', and subsequent women's suffrage demonstrations, and in 1912 was imprisoned for two months with hard labour in Holloway for breaking a Post Office window during a demonstration. Saunders took part in the Women's Social and Political Union's 'Coronation' procession (17 June 1911), representing one of the 700 women's suffrage campaigners imprisoned by the British government (Gliddon n.d.).

5 Salmond, Rutherston and John were Slade friends of Waugh's sister, the artist Edna Clarke-Hall (1879–1979) (Thomas 1994, p. 38).

6 Waugh Hobhouse 1957.

7 Waugh 1908. Waugh gave a public lecture on 'Natural Perspective' at Ealing Town Hall on 8 May 1907, and delivered a paper on 'Construction and Perspective as Preliminaries to the Art of Drawing' at the International Art Congress in London in 1908. Saunders attended both events.

8 Peppin 1996, p. 9. The subject of Litlington was identified in 1995 by the present author; photograph David Curtis.

9 Dickson 2005, p. 17. Roger Fry recruited Etchells into the group of artists painting murals in the dining room at Borough Polytechnic (1911): the others were Bernard Adeney, Macdonald Gill, Duncan Grant and Albert Rutherston.

10 Cork 1975, p. 148. See also Lidderdale and Nicholson 1970, p. 119.

11 Spalding 1980, p. 149.

12 Much of Saunders's work is thought to have been destroyed when her flat in Holborn was bombed in 1940, so her career may never be fully mapped.

13 The name of this street appears with an acute accent ('Phené') in BLAST 2 (1915), p. 7, and in a letter from Saunders to Lewis, c. 1913 (Department of Rare Books, Cornell), but does not normally have one. The local pronunciation is 'Feeny'.

14 In March 1911 Saunders's mother received a substantial legacy from her father, and it seems that shares were then settled on Ethel and Helen, giving each a small independent income. Despite fundamental differences in outlook, Helen Saunders remained close to her immediate family and visited them frequently, but never again lived under the parental roof.

15 Saunders 1962a. She noted that 'Roger Fry in the first Post-Impressionist Exhibition at the Grafton Gallery … had put some of the ideas already working in Paris into circulation in London'.

16 Gruetzner Robins 1997, pp. 52–55.

17 Gruetzner Robins 2014, pp. 58–105.

18 Catalogue of the 1st Exhibition of the Grafton Group, Alpine Gallery, March 1913. I am grateful to Anna Gruetzner Robins for sharing this catalogue. The only paintings at this show to be individually credited were eleven by the American Cubist Max Weber and two by Vassily Kandinsky. The women participants were Vanessa Bell, Mrs Adeney (Thérèse Lessore), Jessie Etchells, Winifred Gill and Helen Saunders.

19 Cork 1975, p. 150.

20 Michel 1971, p. 353, cat. 67. Michel provided this work with its title and date. It originally belonged to Saunders; the facial features closely resemble hers, as do the hands with their prominent knuckles. The photograph of Saunders, taken c. 1916, is reproduced in Lidderdale and Nicholson 1970, facing p. 129 (captioned 'A snapshot taken by Frederick Etchells in about 1916') and Cork 1985, p. 229. The original is currently untraced.

21 Four portraits of Saunders (Michel 1971, cat. 67, 147, 148, 149), dating from 1912–13, were owned by her. Two further portraits of her by Lewis date from c. 1922–23 (Michel 1971, cat. 577, and a drawing now in the Philadelphia Museum of Art. According to Paul Edwards, a further example, exhibited as Seated Woman at the Redfern Gallery (1949) and now lost, was dated 1922 (email communication with the author, 14 February 2022).

22 Saunders 1962a.

23 It was intended that BLAST would appear quarterly, but in the event only two issues were published (June 1914 and July 1915).

24 For details of Dismorr's career, see Stevenson 1974 and Foster 2019. The eleven were poets Richard Aldington, Malcolm Arbuthnot and Ezra Pound and visual artists Laurence Atkinson, Jessie Dismorr, Henri Gaudier-Brzeska, Cuthbert Hamilton, William Roberts, Helen Saunders, Edward Wadsworth and Wyndham Lewis.

25 However, the first issue included a short story, 'Indissoluble Matrimony', by Rebecca West, whose name was given in full. Saunders's surname appeared as 'Sanders' in BLAST and in the Doré Galleries' Vorticist exhibition. Her immediate family knew of her affiliation to Vorticism, but she wished to spare them social embarrassment by publicly announcing her membership of a shockingly avant-garde group. At that time, 'BLAST', as an expletive, was considered even more blasphemous than 'Damn'.

26 The reason for this is unknown; were they not asked to do so?

27 The original pen drawing, which measures 26.9 × 23.1 cm, is now in the David and Alfred Smart Museum of Art, University of Chicago (The Joel Starrells Jr. Memorial Collection 1974.275).

28 Saunders 1962a. In her letter to William Wees, she described these drawings as 'both abstract'. See also here below cat. 8, n. 21.

29 Cork 1976, p. 424.

30 Etchells's choice of a literary source for Saunders's image recalls his role as a tutor on the course on black-and-white drawing for reproduction at the Central School in 1909–10, since the syllabus would have encompassed book illustration.

31 Gruetzner Robins, 2014, pp. 64, 69, 92–93, illus. p. 103.

32 Antliff 2010, p. 582. Antliff argues that Weber's painting would have stimulated Lewis's small pen-and-ink drawing New York (1914), and points to Alvin Langdon Coburn's photographs of New York exhibited at the Goupil Gallery in October 1913 as another likely source.

33 Chipkin and Kohn 2021. Lewis's oil portrait Praxitella (142 × 101.5 cm) is in Leeds Art Gallery. It dates from the period when Saunders and Lewis were estranged.

34 The one exception was a photograph of Gaudier-Brzeska's sculpture Head of Ezra Pound, BLAST 2, p. 84. Paul Edwards suggests that an untitled 1914 Vorticist composition in pen and wash by Etchells was also initially intended for publication in BLAST 2 (email communication with the author, 13 June 2022).

35 Richard Warren (https://richardawarren.wordpress.com/helen-saunders-a-little-gallery) first questioned the orientation of Monochrome abstract composition.

36 Ball (1882–1918) had dropped out of Cambridge to study art in Paris, and became friends with the 'Bloomsbury' writer David Garnett (Garnett 1955, pp. 83–84, 166–68). He and Saunders were very close but, according to a relative, a letter that Saunders wrote to him proposing marriage was intercepted by his mother and destroyed (Godfrey 1995). Ball died of typhus fever in December 1918 while working with refugees in Warsaw.

37 Saunders remained friends with Waugh, who had been imprisoned (May–August 1916) after refusing to pay a fine for distributing pacifist literature. She had married Stephen Hobhouse in 1915.

38 Among the Vorticists, Lewis, Wadsworth, Roberts and Gaudier-Brzeska enlisted for active service. Gaudier-Brzeska, whom Saunders considered 'the most considerable artist among us' (Saunders 1962c) was killed on 5 June 1915.

39 For example, Marinetti 1909: 'We will glorify war – the world's only hygiene'.

40 I am grateful to Jo Cottrell for alerting me to this prospectus, which indicates Saunders's central role in the Vorticist project. (Pound also proposed ateliers in Representational Painting, Portraiture, Etching, and the History of Occidental Painting – to be taught by Reginald Wilenski – and courses in Music – under Arnold Dolmetsch – Letters, Photography, Crafts and The Dance.)

41 Most of the works were credited using the artists' surnames alone; the exceptions were Duncan Grant, who participated in the show by invitation and was identified by his full name, and Lewis, who hyphenated his second forename and surname, presenting himself as 'Wyndham-Lewis'.

42 Quinn (1870–1924), a discerning collector of modern art, had been involved in the 1913 Armory Show, and was the artist Gwen John's most regular patron.

43 Cork 1985, p. 229.

44 See Jo Cottrell's essay in the present volume. See also Beckett 2000, p. 64.

45 Around 21 drawings and eight oil paintings by her from this time are either extant or are listed in exhibition catalogues.

46 Cork 1985, p. 229.

47 In common with his other colleagues, Saunders bought drawings from Lewis when his creditors became pressing. (She owned at least eleven, some of which may have been gifts). Payment for the Tour Eiffel murals

probably took the form of free meals (Cork 1985, p. 234).

48 They had been bought by John Quinn and were sold after his death. They were found, uncatalogued but with sales tags and pencilled titles, in the collection of a private college in Chicago by Richard Born, and were authenticated by Mark Antliff. They are now in the Smart Museum of Art at the University of Chicago.

49 Only two of Saunders's other surviving Vorticist works carry signatures.

50 Kelly 2021, citing Coll 1919. Coll cautions his readers against these shocking dance forms. See also Tickner 2000, pp. 99–115.

51 The Ballets Russes visited London in 1911, 1913 and 1914, and again in September 1918, when Saunders attended three performances in one week.

52 Saunders 1962a.

53 Wadsworth 1914, p. 125.

54 Vassily Kandinsky, quoted in Ibid., p. 121. Kandinsky sent works to the Allied Artists Association annual exhibitions in London from 1909 to 1913 (Gruetzner Robins 1997, pp. 132–34) and was represented by two watercolours in Fry's 1913 Grafton Group exhibition (Gruetzner Robins 1914, p. 64), so Saunders would have undoubtedly known his work.

55 E.g. Cork 1976, pp. 416–17. Cork discusses the hypothesis 'that a feminine temperament was congenitally incapable of sustaining the amount of aggression needed to create a convincing Vorticist work of art'. See also Peppin 1996, pp. 10–11.

56 Saunders 1962b.

57 Saunders 1962c.

58 Others in Saunders's circle who devoted themselves to causes included Rosa Waugh and Reynolds Ball (pacifism), Katie Gliddon (women's suffrage), Harriet Weaver (Communism) as well as four of her aunts.

59 For example Cork 1976, p. 419. Cork unquestioningly relays the disparaging accounts, arguably prompted by personal disappointment, that were given by Etchells and Rebel Art Centre founder Kate Lechmere when he interviewed them in their old age.

60 Wyndham Lewis Memorial Trust archive. The undated letters apparently span a four- to five-year period.

61 O'Keeffe 2000, pp. 163–67.

62 Ibid., p. 212. In February 1919 Lewis developed Spanish flu followed by double pneumonia;

Saunders's sister Ethel arranged for his admission to the Endsleigh Palace Hospital for officers, probably saving his life.

63 Ibid., pp. 218–220.

64 Lewis 1950, p. 137.

65 Saunders 1917.

66 Ibid.

67 Peppin 1996, p. 17.

68 She exhibited as a non-member with the London Group in 1930 and 1931, and with the left-wing Artists' International Association in 1940, subscribing to the AIA as a 'professional member' from 1942 until at least 1960.

69 They included Katie Gliddon, Rosa Waugh Hobhouse, Edna Clarke-Hall and designer and art patron Madge Pulsford.

70 Helen Peppin, interview with the author, July 1995. Sickert presented Saunders with an artwork, usually inscribed, on each of his frequent visits to her studio in 1922. Fifteen of his own etchings and one by Whistler, three drawings and five inscribed reproductions were in her collection, many of them later gifted by her sister Ethel to the Victoria and Albert Museum. Another relative recalled seeing 'squared up canvases for Sickert' in Saunders's flat in the late 1920s and/or 1936/37 (Littlewood 1995), indicating that the friendship was maintained.

71 Foster 2019.

72 Stevenson 2000, p. 9. Saunders owned three landscape watercolours by Dismorr. According to Stevenson, Dismorr's collection of works by other artists, dispersed after her death, was unrecorded (informal conversation with the author, October 2021).

73 Lewis 1919, p. 51. Lewis affirmed that Cézanne was 'at the "bottom" of Cubism'. Saunders's copy of Lewis's collection of essays The Caliph's Design (author's collection) was well-thumbed.

74 Ibid., p. 55. According to Lewis, 'Braque appears to have been the innovator in Cubism'. Saunders spoke of her admiration for his work during a chance meeting with the present author in a central London gallery in c. 1961–62; this conversation later enabled the recognition of L'Estaque as the subject of nine of her early 1920s watercolours.

75 For example, the representation of the receding succession of roofs in the middle distance.

76 Schiff 1984, chapter 13.

77 Bell 1914, p. 173. Saunders owned the 1931 reprint of this work, a gift from Dismorr.

78 Bazin 1964, p. 140.

79 Blunt 1953, pp. 292–93.

80 A relative of Saunders described seeing (in 1936/37) fruit 'gently rotting in bowls as she hadn't finished the paintings!' (Littlewood 1995).

81 Goldschneider 1938 (author's collection). The 244 mainly black-and-white illustrations include many half-length portraits and images of saints.

82 Peppin 1996, p. 19.

83 Stevenson 1974 and Foster 2019.

84 See also cat. 4. Blanche Caudwell, daughter of an Ealing clergyman, worked as a hospital almoner and later for the Invalid Children's Aid Association. A relative of Saunders described Caudwell as a silent person who 'liked sitting still', and thought that they were flat-sharers for mainly economic reasons. Saunders's income from shares gradually declined, and Caudwell was not well-off (Helen Peppin, interview, July 1995). The fact that they were friends from c. 1910 or earlier, but did not share an address until c.1933, may support her view that they were friends rather than partners. After Caudwell's death, Saunders had to move quickly to cheaper rooms.

85 *Red curtain* is painted on the reverse of an early oil landscape, perhaps of Deal in Kent, where her parents had a cottage. Saunders's frequent re-use of canvases in the 1940s and 1950s may reflect post-war shortages, or her increasing poverty.

86 In 1958 Saunders's friend Madge Pulsford proposed to bequeath a portrait of herself by Saunders to the Tate, an offer that was refused (Peppin 1996, p. 41). *Portrait study* (fig. 22) may be a preparatory study for this work. Pulsford had been one of two sitters for Etchells's painting *The Big Girl* (Tate) and was the subject of four drawings by Lewis in 1919–20 (Michel 1971, cat. 373, 394, 417, 418).

87 Though these recall the self-portraits of the Finnish artist Helene Schjerfbeck (1862–1946), Saunders is unlikely to have encountered her work, which remained little-known in Britain until the twenty-first century.

88 Saunders 1962d. Saunders seems to be responding to an earlier suggestion by Waugh Hobhouse that she should be more proactive in promoting her work.

89 From 1949, Saunders submitted work to the annual Holborn Art Exhibition, held every November in Holborn Town Hall. In 1955 the 'Guest of Honour' was John Betjeman; in 1957 the selection and hanging committee consisted of three relatively well-known professionals – Claude Rogers, James Fitton and Edwin La Dell ('The Holborn Guardian', Holborn Library). *Portrait study* (fig. 22) is one of several paintings by Saunders that carry a Holborn Art Exhibitions label.

90 39 Gray's Inn Road, where Saunders rented the top floor, dated from c. 1700; it retained its original interior but was re-faced in the nineteenth century. Around 2017 the building and the adjoining houses were replaced by offices disguised by fake Georgian façades.

91 Castner 1963.

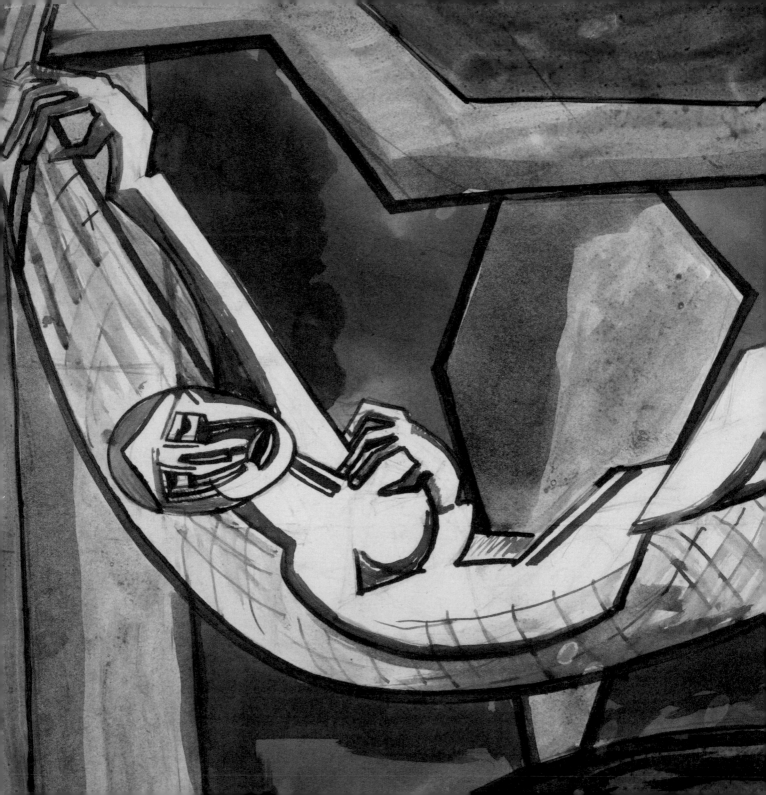

Helen Saunders as Vorticist – a discreet yet revolutionary spirit

Jo Cottrell

Following Helen Saunders's death in 1963, the artist's sister Ethel M. Saunders presented three Vorticist designs to the Tate Gallery, explaining that they were probably created in 1915 when Saunders was helping Wyndham Lewis with the decorations for the Restaurant de La Tour Eiffel, a fashionable eatery situated at 1 Percy Street on the fringes of Soho.[1] Lewis and Saunders collaborated on a project to create a 'Vorticist room' on the first floor of the restaurant. The exact nature of their individual contributions to the project remains unclear, even though Lewis was credited with the entire scheme. The subtle nature of Saunders's involvement with the commission is comparable with the intentional obfuscation of her identity as a member of the Vorticist group, with Saunders's name appearing as 'H. Sanders' amongst the signatories of the Vorticist manifesto in *BLAST*.[2] The obscuring of Saunders's public profile as a rebel artist, as announced in an avant-garde magazine that today still possesses an arresting power, foreshadows the uncertain position that this artist has hitherto occupied within the historiographies of Vorticism. Saunders's veiled identity, coupled with residual assumptions that as a Vorticist she was subordinate to Lewis as the self-appointed spokesman for the movement, emphasises the challenges historians have faced when attempting to develop a more rounded understanding of Saunders's contribution to early modernism in Britain and abroad.[3] The disappearance of much of Saunders's early work and the dearth of biographical information has hampered research and obstructed arguments for the artist's centrality to the Vorticist project. Such problems have been compounded by the gaps and silences in the historiographies of English modernism that continue to mask the contributions made by women, these lacunae within Vorticism obscured yet further by the unfortunate repetition of unreliable anecdotes and statements of dominance made by Saunders's contemporaries.[4] Most prominently, Lewis's controversial claim that 'Vorticism, in fact, was what I, personally, did, and said, at a certain period', made on the occasion of the Tate Gallery's retrospective exhibition *Wyndham Lewis and Vorticism* in 1956, effectively relegated all of Lewis's Vorticist collaborators and many of his modernist contemporaries to the periphery of his project.[5]

Lewis's claim for primacy as interpreted by the Tate exhibition caused consternation at the time, provoking the ire of fellow group protagonist William Roberts (1895–1980) and irritating others involved in the show.[6] In 1961, by way of redressing the balance, Roberts was working on his now emblematic painting, *The Vorticists at the Restaurant de la Tour Eiffel: Spring 1915* (fig. 24). The painting offers, in Roberts's own words, an 'imaginative evocation' of the Vorticists,[7] that is an altogether more playful rendering of the individuals Roberts considered to be the central protagonists of the group. Much has been written about this work,

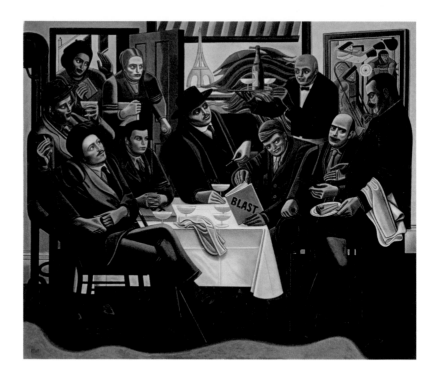

24 William Roberts, *The Vorticists at the Restaurant de la Tour Eiffel, Spring 1915*, 1961–62, oil on canvas, 182.9 × 213.4 cm. Tate, T00528

[handwritten annotation:] women = peripheral status

which is an amalgam of moments and a document of key features of the group dynamic and the personalities involved, rather than the depiction of a specific event.[8] It has often been cited as Roberts's commentary on the perceived peripheral status of the women working under the banner of Vorticism,[9] due to the artist's positioning of Saunders and fellow *BLAST* signatory Jessica Dismorr within the composition.[10] However, if one looks back at how the 'rebel' women were viewed by one Vorticist contemporary in 1914, a different picture emerges. In his review of the Allied Artists' Association exhibition of June 1914, Henri Gaudier-Brzeska singled out Dismorr and Saunders by name in order to recommend their contributions, commenting that '[P]eople like Miss Dismorr, Miss Saunders ... are well worth encouraging towards the new light. With them stops the revolutionary spirit of the exhibition.'[11] Indeed, Lewis himself said of Vorticism in 1957, '[I]t was essential that people should believe that there was a kind of army beneath the banner of Vorticism. In fact there were only a couple of women and one or two not very reliable men,'[12] demonstrating their centrality to a multifarious Vorticist project. As the present exhibition looks afresh at Saunders's life and work and argues for her importance as a pioneering artist active at the nexus of modernist

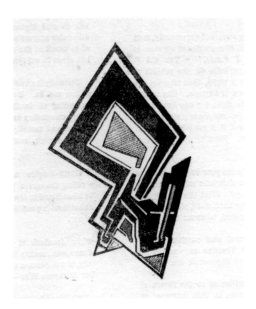

25 Helen Saunders, illustration in *BLAST* 2, 1915, black and white line block reproduction, 91 × 49 mm, p. 16

one of the earliest vorticist works

activity in the 1910s, closer attention is paid to the social terrain on which Saunders operated to help amplify her presence as a key participant.[13] Drawing on new archival material that now prompts a re-assessment of Saunders's surviving work of the pivotal year of 1915, the setting for Roberts's pictorial gathering and Saunders's position within it can now be reappraised to allow this artist to take her rightful place at the Vorticist dinner table as a true revolutionary.

In his memoir *South Lodge,* the writer and journalist Douglas Goldring recalls receiving an invitation to 'a *Blast* dinner, held in the room in the Eiffel Tower Restaurant ... which Lewis had decorated for its proprietor Rudolf Stulik'.[14] The dinner in question clearly had the promise of being a boisterous affair, Goldring reporting that his 'guru' did not allow him to attend, speculating that 'he thought I might spend too much of my own money and perhaps return rebelliously intoxicated'.[15] Goldring's invitation probably referred to a 'Vorticist Evening' that took place on 23 February 1916 to mark the official opening of the 'Vorticist Room',[16] one of a number of events and opportunities to view the decorations that were organised for the press, members of high society and the cognoscenti of London's art world.[17] Stulik was a popular Viennese chef,[18] known among his friends and clientele as the 'Burgomaster of Soho',[19] and, whilst members of high society were frequent visitors to his restaurant, it was also a magnet for artists, writers and the demi-monde during World War I and into the 1920s.[20] This was largely due to the proprietor's generosity towards the avant-garde and his encouragement of their activities.[21] Stulik's establishment was conveniently placed for Lewis, who had lodgings in Percy Street in 1914, moving to nearby Fitzroy Street in 1915.[22] During this period Lewis's rooms became the meeting place for the Vorticists, the group often continuing their discussions at the Tour Eiffel thanks to Stulik's enthusiasm and his admiration for Lewis as an artist and as a regular visitor.[23] 1915 was a significant year for the Vorticists with the group's activities at their height before the inevitable intervention of the war, as individual members dispersed to assist in its effort.[24] The first Vorticist exhibition was launched at the Doré Galleries in New Bond Street in June, and in July the second number of *BLAST,* the 'War Number', was published. Saunders was central to Vorticist activities at this time, contributing four 'pictures' to the Doré exhibition: *Atlantic City, English Scene, Swiss Scene* and *Cliffs*, along with two works on paper, *Island of Laputa* and *Black and Khaki. Atlantic City* and *Island of Laputa* were also reproduced in black and white in the second number of *BLAST*.[25] A further tailpiece design printed in *BLAST 2* has also been attributed to Saunders (fig. 25).[26] In addition, Saunders assumed an administrative role for the group with her Phene Street address in Chelsea given in the magazine as the point of contact for those wishing to receive copies.[27]

As it captures the essence of this significant period for the Vorticists, Roberts's painting allows the viewer to imagine the individual journeys that each of the key protagonists may have taken as they arrived at the restaurant to celebrate their successes and to discuss future plans.[28] Lewis would have had to walk but a few steps from his rooms to be greeted as a regular and a favourite at Stulik's establishment.[29] One might envisage Ezra Pound visiting a publisher or two along the way as he made his way to Percy Street on foot, better to display his bohemian credentials by looking "every inch a poet".[30] Dismorr, one might reasonably surmise, had travelled through London's West End on the top deck of an omnibus, the journey offering this artist the opportunity to view the cityscape and its throng; the purse Dismorr is seen holding in the painting is perhaps more likely to have been a notebook serving to record the fleeting observations made along the way and used as inspiration for her poetry.[31] Saunders, as Roberts visually recalls, is an individual with a serious attitude. She has a determined look on her face, a copy of *BLAST* held firmly under her arm as she enters the restaurant, as if having completed a useful day's work whilst organising the distribution of Vorticist publications. Self-confessed as being 'solitary by nature', Saunders nonetheless arrives at the Tour Eiffel with an air of purpose, amused by the prospect of a boisterous evening yet relishing the opportunity to envisage a new project.[32]

By the time Stulik gave his consent that Lewis should decorate one of the first-floor rooms of 1 Percy Street, Lewis's reputation for creating designs for interior spaces was well documented, and the prospect of financial benefits and opportunities for self-promotion that these projects allowed him had the potential to rise accordingly.[33] Lewis's increasing prominence as an artist of London's avant-garde had been marked in 1912–13 by the striking decorations he produced for Frida Strindberg's notorious cabaret space known as the Cave of the Golden Calf.[34] Whilst there is no direct evidence to suggest that Saunders was involved with the group of artists working on Strindberg's cabaret project,[35] Saunders's retrospectively titled *Cabaret* (cat. 9) indicates a keen interest in the frenetic rhythms of early jazz performances promoted by Strindberg in her club.[36] Indeed Saunders's design would not look out of place if used on a poster to promote Strindberg's exciting musical programme. Lewis's much-publicised contributions to the cabaret's aesthetic would lead to the hiring of the artist and 'his allies' by other notable patrons to decorate spaces in their private residences.[37] For the Tour Eiffel commission Cork documents that several friends 'acted as Lewis's informal assistants', making passing reference to artists Peter Keenan (1896–1952) and Richard Wyndham (1896–1948), two young men who may have been drafted in as trainees.[38] Cork refers to Saunders as 'the most able of helpers', acting as Lewis's main 'assistant' on the

HS seen as helper not integral to movement

32

commission,[39] his words acknowledging Saunders's talent as an artist but at the same time relegating her to a subordinate position.

The exact nature of the 'Vorticist room' and its decoration remains unclear, and attempts to attribute individual contributions to the scheme are fraught with difficulty. Fragments of information provide valuable clues, however. William Roberts remembered that 'Lewis painted three abstract panels' for the room, though the 1938 auction catalogue for the sale of the restaurant's contents on the occasion of the Tour Eiffel's closure only mentions 'two wall panels'.[40] This leads Cork to speculate that a third 'panel' may have been a mural.[41] Cork also refers to a tantalisingly short review of the room published in the April 1916 edition of *Colour* magazine which reported that 'gay vorticist [sic] designs cover the walls, and call from the tablecloth', suggesting to him a cohesive decorative scheme.[42] The vivid nature of the scheme was also commented upon in the subsequent issue of *Colour*, the commentator noting the 'provocative and arresting power' felt when confronted by the decorations, adding that 'the appeal of the colour is undeniable'.[43] Decisive information about the Vorticist room is provided by the artist and frequent visitor to the restaurant Harry Jonas (1893–1990), both in connection to the nature and possible subject matter of the designs and their location. Jonas recalled the decorations as 'semi-abstract Buildings, etc., very "Gothick", strong lines and flat patches of colour: a geometrical treatment'. The colours, according to Jonas, were 'bright red and green' and 'very "raw"' whilst at the same time having 'the effect in the room of being on the low-toned side'.[44] Crucially, Jonas also remembered clearly the position of one of the designs, being a 'big one between the windows'.[45] All of these important recollections and fragmentary pieces of information are now enhanced by two new discoveries that provide tantalising insight into how the 'Vorticist Room' may have appeared to visitors.

On 15 January 1916 the *Pall Mall Gazette* published a report on the recent completion of the Vorticist room at the Restaurant de La Tour Eiffel.[46] Carrying the headline 'The Vorticists. Perils of a West End Restaurant', the report adopts a jocular tone as it describes the room, referring to 'walls that shriek' and demonstrating a level of affected bemusement when confronted with 'paintings [that] have happened somehow to be in the places they occupy'.[47] Apparently no Vorticists were present when the writer viewed the room and marvelled at 'a frieze of dazzling blue and gold', but a notable reference is made to an explanatory card described in the article as 'the only thing that is at all likely to prevent confusion' between the designs listed and as seen on the walls.[48] According to the report the card listed the designs under two headings, 'Paintings and Ornaments' and 'Drawings', with specific works titled *Two Silhouettes* and *A Pleasant Column* listed as 'Paintings and

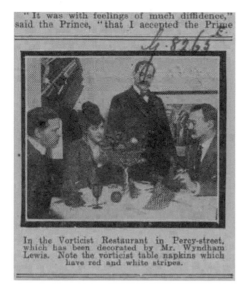

"It was with feelings of much diffidence," said the Prince, "that I accepted the Prime

In the Vorticist Restaurant in Percy-street, which has been decorated by Mr. Wyndham Lewis. Note the vorticist table napkins which have red and white stripes.

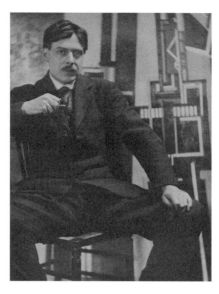

26 'In the Vorticist Restaurant in Percy-street', photograph, *Daily Mirror*, 18 January 1916, p. 2

27 *Wyndham Lewis* (collotype photograph by Alvin Langdon Coburn, 25 February 1916). National Portrait Gallery, NPG AX7830

Ornaments' and *Meat and Drink, Two European Lovers* and *Mother and Child* listed under 'Drawings'.[49] The report also informs the reader that '"Meat and Drink" is near the door, and the portrait "Mother and Child" at the opposite side of the room'.[50] A few days later, on 18 January 1916, the *Daily Mirror* printed a small photograph of the 'Vorticist Restaurant' (fig. 26). Three anonymous diners are pictured in conversation, seated at what appears to be a table in the corner of the room, as a formally dressed and clearly identifiable Stulik serves wine. Two Vorticist designs are discernible on each wall behind the group. To the right of the scene a framed work is visible, behind Stulik and one of the male diners, and to the upper left another unframed design can be seen in what appears to be a recess, the design itself apparently painted directly on to the wall and partly obscured by what may be the breast of a chimney. The photograph carries the caption:

HS no edit

> In the Vorticist Restaurant in Percy-street, which has been decorated by Mr. Wyndham Lewis. Note the vorticist [sic] table napkins which have red and white stripes.[51]

No photographs of the Vorticist room have hitherto come to light, despite the extensive efforts of Cork.[52] The emergence of the photograph and the listing of works reported in the *Pall Mall Gazette*, combined with

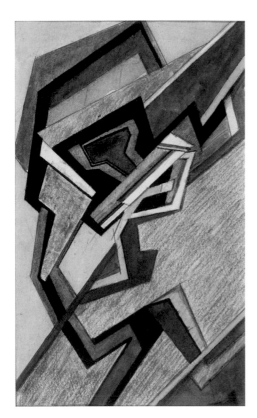

28 Helen Saunders, *Abstract composition in blue and yellow*, c. 1915, graphite, coloured chalks and watercolour on paper, 276 × 171 mm. Tate, T00623

the fragments of information gleaned by Cork, may now allow for more accurate hypotheses, the photograph adding a further conundrum as to the specific location of the Vorticist room on the Tour Eiffel's first floor. Additionally, the compositions by Saunders gifted to the Tate Gallery by Ethel Saunders in the 1960s, together with those now in the Courtauld collection, may be analysed anew in the light of these discoveries. This new source material prompts a reassessment of Saunders's Vorticist work to argue for her having been a significant contributor to the Tour Eiffel project.

The colour palette applied in Saunders's *Abstract composition in blue and yellow* (fig. 28) could be reasonably connected to what eventually became the 'frieze of dazzling blue and gold', as reported in the *Pall Mall Gazette*.[53] Similarly, Saunders's *Vorticist composition in blue and green* (cat. 14) accords with the 'dazzling' reference in the article. However, the orientation of Saunders's Tate design does not easily lend itself to the horizontal nature of a frieze, and the economical use of blue pigment in *Blue and green* does not align with the description in the report.[54] On closer inspection the framed design visible in the *Daily Mirror* photograph reveals striking similarities to Lewis's 1914 drawing *Red Duet* (fig. 29). Paul Edwards has argued that the large painting visible in the background of a well-known photograph by Alvin Langdon Coburn (fig. 27), picturing Lewis seated in his studio on 25 February 1916, could be the now lost painting of the same title,[55] this work also having been included in the Vorticist exhibition at the Doré Galleries in June 1915.[56] Lewis's *Design for Red Duet* (fig. 30), reproduced as a black and white print in the second number of *BLAST*,[57] has clear similarities with the work visible in Langdon Coburn's photograph and shares the vivid blue and yellow palette of Saunders's *Blue and Yellow* composition. The photograph was taken two days after a 'Vorticist Evening' was held at the restaurant,[58] and could therefore constitute another promotional vehicle for Lewis's work on the Tour Eiffel project. It is thus reasonable to speculate that Lewis's design may be connected to the frieze reported in the *Pall Mall Gazette*.

The Vorticist design seen to the left of the *Daily Mirror* photograph is more difficult to assess, hampered by the grainy nature of the newsprint. The lower part of the geometric design visible is composed of straight lines at angles that appear to thrust upwards towards the right hand area of the dark shaded background, the whole composition set against and contained within a background of lighter shade that accommodates the upward trajectory of the lines. The lighter thin rectangular elements reveal a uniform series of short parallel lines that stem from the darker blocks of shading. Whilst the upper section of the design is more difficult to discern, elements of the design's lower section have similarities with the study for Saunders's *Vorticist composition, black*

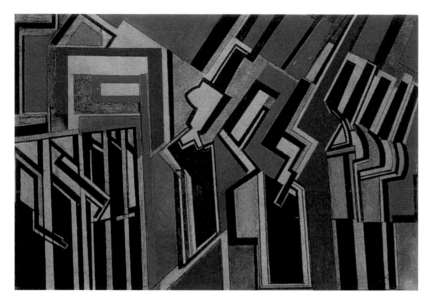

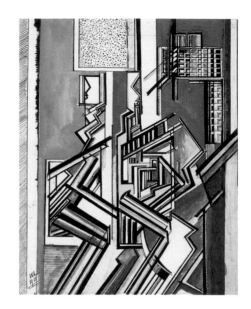

29 Wyndham Lewis, *Red Duet*, 1914, black and coloured chalks and bodycolour on paper, 385 × 560 mm. Ivor Braka Ltd, London

30 Wyndham Lewis, *Design for Red Duet*, 1915, graphite, pen and ink, watercolour and bodycolour on paper, 313 × 250 mm. Private collection

and white (cat. 10), for which there is a further study held at the Tate (fig. 31). Each of these designs shares an affinity with Saunders's *Vorticist design*, also held at Tate (fig. 32), as well as the tailpiece attributed to Saunders that can be seen on page 16 of *BLAST*'s second number (fig. 25). These similarities suggest that the four works may be part of a scheme of designs made in preparation for a mural at the Tour Eiffel. Until now it has been difficult to ascertain whether Saunders had been working on a large scale as a Vorticist. However, the recent and highly significant probable rediscovery of Saunders's painting *Atlantic City*,[59] a painting that had been exhibited at the Vorticist exhibition alongside Lewis's lost *Red Duet* and *Design for Red Duet*, provides compelling evidence that Saunders was producing sizeable work. Furthermore, the current and ongoing project to realise a colour reconstruction of *Atlantic City* demonstrates that Saunders was boldly experimenting with an audacious palette to match the virtuosity of her designs during this period of Vorticist activity.[60]

The discovery of the *Daily Mirror* photograph also prompts renewed speculation on the possible size and probable location of the Vorticist room at 1 Percy Street. Whilst it is impossible to determine exactly the dimensions of the room and the nature of its partition from the rest of the floor, an argument can be made for its prominence as one of the two dining spaces occupying the front of the first floor. If the wall partially obscuring the Vorticist design in the recess is the breast

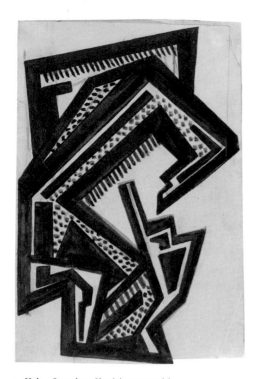

31 Helen Saunders, *Vorticist composition, black and white [large]*, c. 1915, graphite and ink on paper, 184 × 118 mm. Tate, T15090

32 Helen Saunders, *Vorticist design*, c. 1915, graphite, ink and watercolour on paper, 256 × 176 mm. Tate, T15089

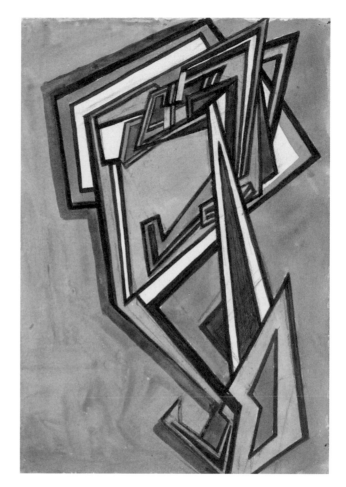

of a chimney (as seen behind the diner to the left of the photograph), the image captures the back corner of the room at the front of the building at its eastern end. A recent inspection of the premises shows that a doorframe currently exists further along the wall carrying the framed picture visible in the photograph. According to the *Pall Mall Gazette* report, '"Meat and Drink" is near the door', while the visceral palette of the existing *Red Duet* accords with Jonas's memory of works in the Vorticist room as 'very raw'.[61] More significantly, the report that 'the portrait "Mother and Child" [was] at the opposite side of the room'[62] makes it reasonable to suggest that the footprint of the Vorticist room

33 Helen Saunders, *Abstract multicoloured design*, c. 1915, bodycolour, watercolour and graphite on paper, 359 × 257 mm. Tate, T00624

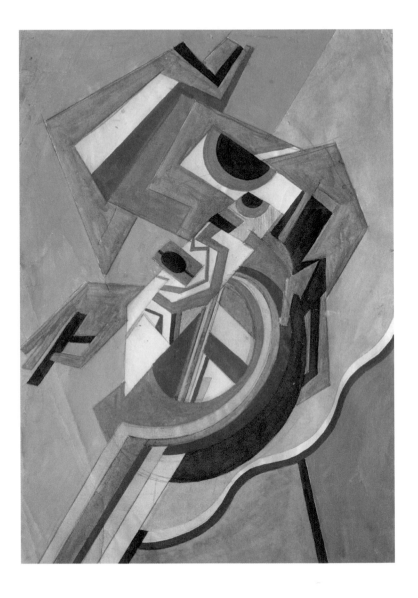

accommodated two of the front windows to the east of the premises, particularly in the light of Jonas's recollection of one of the Vorticist designs being the 'big one between the windows'.[63] This raises a conundrum, as in the auction catalogue the Vorticist room is listed as 'The Left Front Room'.[64] Whether or not this was meant to indicate the room at the left side of the building as one entered at street level, or if the

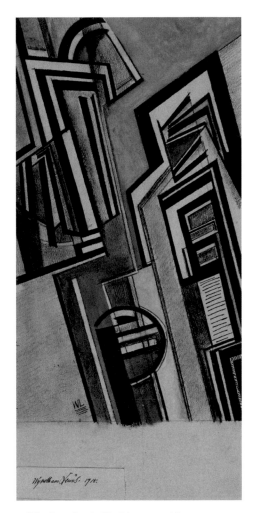

34 Wyndham Lewis, *Vorticist composition*, 1915, bodycolour and chalk on paper, 375 × 173 mm. Tate, T00625

catalogue as printed was in error, is impossible to know. However, one of the items listed for auction in the room seems, as Cork has commented, antipathetic to Lewis's supposed intentions, namely the 'mechanical clock in painted pedestal case, with rotating figures of the twelve apostles'.[65] Cork also comments on the sober furniture and austere grey pile carpet available for auction: whilst he sees these as items for which Lewis may reasonably be held responsible, they seem unusually conservative given the radical decoration of the Vorticist room. The tantalising idea that the Vorticist decorations may have occupied the larger of the two dining rooms on the first floor adds further weight to the scale of the project and for Saunders's contribution to the overall scheme.[66] Significantly, it is on record that 'when he was the Prince of Wales the Duke of Windsor often gave dinner parties in the room decorated by Wyndham Lewis'.[67] It is difficult to imagine that these occasions did not warrant the space in which to do them justice.

The two other designs by Saunders gifted to the Tate Gallery in 1963 provide further basis for informed speculation about the nature of the decorations in the Vorticist room when considered in conjunction with the *Pall Mall Gazette* report. The corporeal elements discernible in Saunders's *Abstract multicoloured design* (fig. 33) appear to undermine its (retrospectively given) title, thus offering an opportunity to consider the work's title at the time of its execution. The eye is drawn to the left of the composition, where a hand set against a pale blue background is clearly discernible, the index finger highlighted in red set in contrast to the ochre of the thumb and two other outstretched digits, the little finger highlighted in red as it bends into the palm of the hand. Directly below the hand a curved patch of a lighter shade of red juts to a point, the curve forming part of a sickle shape, a motif that, as Cork has identified, is echoed in Lewis's *Vorticist composition* of 1915 (fig. 34), a work that was owned by Saunders.[68] In Saunders's composition the sickle shape radiates outwards by four separate patches of colour as if to accentuate the rounded shape of a torso. To the right of the composition another hand can be observed as it supports the outer limit of the curve, thumb and fingers defined in ochre whilst the index and one other digit are again highlighted in red. The arm of the Vorticist body is clearly visible as the shoulder is raised upwards as if to aid the arm as it supports the torso. The figure's powerful neck merges with the back of its head, which appears to be wearing a hat, the head bowed down towards the right hand. The facial features are rudimentary, suggested by the lighter red inverted L-shaped area, the hairline suggested by a patch of blue. Another inverted L-shaped patch of off-white pigment containing circular and linear forms in pink and red appears to rest upon the torso supported by the left hand, whilst the right hovers above it as if to shield the form from external threat.

Corporeal references can again be seen in Saunders's *Monochrome abstract composition* (see fig. 8, p. 14), also titled retrospectively, with elements of the design echoing those of *Abstract multicoloured design*. Three uniform figures also carry rudimentary facial features in the monochrome design, and if the design is inverted the figures are balanced on each other's shoulders along the line of a column that thrusts diagonally upwards from the bottom left hand corner towards the top right, as if moving along a conveyor belt.[69] Each has a semi-circular design on its torso that appears to engage in dialogue with a large curve that emerges from behind the right arm of the lower figure, arching round to the right and backwards underneath the column to connect with a smaller crescent to the middle left, creating an S shape. This semi-circular design also appears in the aforementioned *Vorticist composition* by Lewis (fig. 34) and again as a small detail in Lewis's *Vorticist composition in red and mauve* (fig. 35), another work in Saunders's possession at the time.[70] As the central figures in Saunders's monochrome design appear to move in unison along the column towards the upper right, three other featureless bodies in a darker shade interact with the column as if to support it, the two to the right apparently holding the column up whilst the third ancillary body dives down from the top left as if to steady the column as it is pulled upwards. When these two studies are considered together with the list of designs recorded as printed on the explanatory card, and in the case of *Abstract multicoloured design* with the fragmentary descriptions of the colour scheme of the Vorticist Room, it becomes viable to link them as possible studies for two of the titles listed: *Abstract multicoloured design* to *Mother and Child*, and *Monochrome abstract composition* to *A Pleasant Column*. Saunders's evident interest in the subject of mother and child during this period can be substantiated by two ink-and-wash studies on paper that she made on the theme after 1914 (cat. 3a and 3b). Both studies show a mother holding her child to her breast, left hand in the foreground supporting the child and right hand, the digits clearly visible, protecting the child from behind. The body discernible in *Abstract multicoloured design* is in a similar position to those of the mother and child studies. The left hand seen in the Vorticist *Design* supports the rounded torso as a swaddled infant rests upon it, protected by the bowed head and outstretched right hand. Paul Edwards has suggested that *Abstract multicoloured design* may be read in Vorticist terms as 'showing the tension between the new mechanized sense of self and a traditional sense of the body as a site of maternity'.[71] Combined with Jonas's recollection of the position of a large Vorticist work and the *Pall Mall Gazette*'s report on the location of *Mother and Child* this provides tantalising evidence that Saunders's *Abstract multicoloured design* may be a study for the Vorticist design that occupied the space between the windows of the Vorticist room.

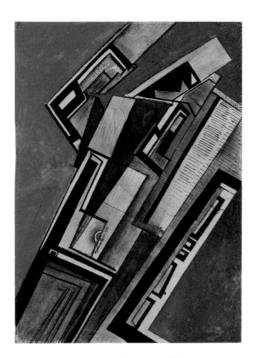

35 Wyndham Lewis, *Vorticist composition in red and mauve*, 1915, pen, ink, chalk and bodycolour on paper, 347 × 245 mm. Museo Nacional Thyssen-Bornemisza, Madrid, 647 (1981.20)

The inverted *Monochrome abstract composition* and *Abstract multicoloured design* each evoke an impression of support and nurture, and as such could function as a playful reference to the support given by Saunders to Lewis as they worked together on the Tour Eiffel commission. Cork has speculated that Saunders 'may have been content to fulfil this subservient role' arguing that 'Lewis would hardly have wanted anyone else's personality to obtrude in an interior which was essentially his own creation'.[72] However, the decision to credit Lewis alone for the commission may well have been Saunders's own. As demonstrated by the deliberate obscuring of her public persona as a Vorticist in *BLAST*, Saunders was likely to have shunned all publicity. As Peppin has remarked, Saunders was probably satisfied to let Lewis take the credit for financial reasons,[73] her acquisition of Lewis's works during this period of collaboration further evidence of her support of the impecunious artist. This reticence to publicity should not be taken as artistic subservience.[74] The assuredness with which Saunders executes her Vorticist works of this period clearly testifies to her independent talents as an artist. The inclusion of figurative elements in the two compositions discussed here may serve as a wry commentary on her friendship with Lewis as collaborator, making a subtle personal stamp on the project. The featureless ancillary figures in *Monochrome abstract composition* that guide the uniformed others as they move upwards along the column may be understood as a reference to Saunders's anonymous, yet willing support of Lewis as he uses the commission to make a name for himself as an artist whose public profile is rising yet threatened by his imminent departure for the Front. It is documented that Lewis was given *carte blanche* by Stulik to decorate the first-floor room, providing the opportunity to create a truly Vorticist artwork at the moment when Vorticism as a movement was taking shape, and with Lewis at the same time in need of a lasting legacy when faced with active war service.[75] In this context *Mother and Child* could therefore refer to Saunders's 'nurturing' of the project with Lewis, the swaddled Vorticist child recently born of the Stulik commission, akin to the birth of the 'problem child' *BLAST* a year previously.[76] Saunders's ancillary bodies in *A Pleasant Column* may be 'faceless' but without their assistance the column carrying the uniform figures will collapse, the S-shaped motif as brand providing a clue as to Saunders's subtle message: without her contribution towards the creation of the 'Vorticist Room' at the Tour Eiffel restaurant, the project could conceivably have not come so easily to fruition.

When Ethel Saunders presented her late sister's Vorticist compositions to the Tate Gallery she told John Rothenstein that the designs were 'probably' done at the time of the Tour Eiffel decorations.[77] Peppin has remarked pertinently that Ethel may not have seen these

compositions prior to Saunders's death and that the sight of them thereafter would be likely to have sparked a memory of the completed decorations *in situ* at the restaurant. Peppin has also observed that if Ethel Saunders had not seen the Tour Eiffel paintings in person it is unlikely that she would have remembered Saunders's part in their creation, especially given that the project was attributed wholly to Lewis, of whom she disapproved.[78] Whilst this information, and the wider hypotheses offered here, do not provide conclusive evidence that the Tate and Courtauld drawings are directly related to the Tour Eiffel commission, these facts, insights and new discoveries offer a considerable contribution to ongoing research into the significance of the women connected to Vorticism and to a greater understanding of the life and work of Helen Saunders as a discreet yet revolutionary spirit at the epicentre of the Vorticist project.

1 Cork 1985, p. 229 n. 50.

2 Lewis 1914, p. 43. The misspelling of Saunders's surname was deliberate and probably done 'in deference to my conventional home background' (letter from Helen Saunders to William Wees, quoted in Wees 1972, p. 178; see also Brigid Peppin's essay in this volume, p. 12). Saunders's name was also misspelled alongside her contributions to the second number of *BLAST* (see Lewis 1915, pp. 3, 4, 8, 57). There exists one anomaly in that the name 'Saunders' appears on the poster for the Vorticist Exhibition held at the Doré Galleries in the summer of 1915. The poster is reproduced in Cork 1976, p. 275.

3 Analysis of the contributions made by women artists as documented within the historiographies of Vorticism began to receive sustained critical attention from the mid-1990s, twenty years after Richard Cork's groundbreaking study of Vorticism (Cork 1976). Cork acknowledged the presence of women within Vorticism and their active contribution to its spaces and its aesthetic, albeit by his own admission from an unconsciously chauvinist viewpoint (Cork 1976, p. 416; Beckett and Cherry 2000, p. 59). Brigid Peppin also refers to Cork's handling of the women Vorticists, suggesting that Cork's study was inevitably influenced by the dominant theoretical frameworks of the 1970s when feminist art history was in its infancy; see Peppin 2010, pp. 590–93. It should be noted that brief acknowledgements of Jessica Dismorr and Helen Saunders as Vorticists have been made by William C. Wees, Charles Harrison and William C. Lipke (Wees 1972, Harrison 1981 and Lipke 1996). For invaluable discussions on women and Vorticism see Beckett and Cherry 1988, 1998 and 2000, Tickner 1994, Peppin 1996, Heathcock 1999, Beckett 2001, Deepwell 2015, Hickman 2013 and 2015 and Foster 2019.

4 See Cork 1976, pp. 150, 418–19.

5 Lewis 1956, p. 3.

6 The Tate exhibition was designed to position Lewis as the dominant figure among a seemingly disparate group of artists who were placed under the banner of 'other Vorticists'; see Cork 1974, p. 5. Lewis exacerbated this situation in his introduction to the exhibition catalogue, where he made the now infamous statement. The exhibition and its methodology sparked Roberts into privately publishing a series of 'Vortex Pamphlets' (1956–58) presenting his case against Lewis and the Tate's then artistic director John Rothenstein, and objecting to Lewis's claim that he was the sole and prime mover within Vorticism; see Brooker 2007, pp. 129–31. Extracts and a discussion on the 'Vortex Pamphlets' can be accessed via a website devoted to the life and work of William Roberts, 'An English Cubist' (http://www.englishcubist.co.uk/vortexpamphlets.html; last accessed 7 March 2022).

7 William Roberts quoted in 'An English Cubist', as note 6.

8 Brooker 2007, pp. 129–31.

9 Wyndham Lewis used this phrase in an interview with *Vogue* magazine in August 1956: 'An English Cubist', as note 6.

10 Heathcock 1999, p. 38.

11 Gaudier-Brzeska 1914, p. 228.

12 Wyndham Lewis quoted in *Vogue* in August 1956: 'An English Cubist', as note 6.

13 In his book *Bohemia in London,* which carries the image of Roberts's painting on its cover, cultural historian Peter Brooker considers the importance of a focus on 'place' as an alternative to the more familiar focus on 'type' to create a better understanding of the cultural landscape of early modernism in the capital (Brooker 2007, pp. viii–ix).

14 Goldring 1943, p. 70.

15 Ibid.

16 Cork 1985, p. 220.

17 A printed invitation card tells us that viewings of the room were available between 11 am and 6 pm from 11 January until 1 February 1916 (see Cork 1985, p. 220, where the card is illustrated). Wyndham Lewis appears to have also hosted various evenings at the Tour Eiffel to show off the decorations. The *Daily Mirror*'s gossip column of 25 February 1916 mentions a party attended by Miss Edith Craig, Miss Christopher St. John and Miss Olive Terry, where Lewis was 'the presiding genius of the ceremony' ('Mr. Wyndham Lewis Enlists', *Daily Mirror,* Friday 25 February 1916, p. 10).

18 Stulik had originally come to London to learn English like many other European professionals: see *The Sphere,* 12 June 1926, pp. 277–79. He took over proprietorship of the Tour Eiffel in 1908 (Cork 1985, p. 214). A contradictory date of 1906 is mentioned in a press report on the closure of the Tour Eiffel in 1937 ('London's "Eiffel Tower"', *Lancashire Evening Post,* Saturday 7 August 1937, p. 4).

19 'The Round of the Day', *Westminster Gazette,* Friday 17 September 1926, p. 8.

20 David 1988, pp. 123–32.

21 David 1988, pp. 126–27; Cork, 1985, pp. 214–16.

22 O'Keeffe 2000, p. 163. William Roberts mentions Lewis's move to 18 Fitzroy Street in early 1915: 'An English Cubist', as note 6.

23 Roberts quoted in Cork 1985, p. 215.

24 Cork 1985, p. 215. Lewis enlisted in March 1916 and saw action at Messines Ridge and Passchendaele in 1917; see Edwards 2000b, p. 167 and Slocombe 2017, p. 16. Dismorr was in France working as a VAD nurse in 1915; see Stevenson 2000, p. 7. Saunders worked full-time for the government; see Peppin 1996, p. 15.

25 Peppin 1996, p. 39.

26 Peppin 1996, p. 24, n. 55.

27 Lewis 1915, p. 7.

28 The Tour Eiffel continued to be a preferred meeting place for some of the rebel artists during the latter part of the war. In a letter to Dismorr, Saunders writes that she met William Roberts for lunch there while he was home on leave from the Front (Saunders 1917). In 1919 Roberts was commissioned by Stulik to decorate the 'lobby' leading into the Vorticist Room, for which he produced three paintings. See Cork 1985, pp. 238–45.

29 Cork 1985, pp. 215–16.

30 In his autobiography Douglas Goldring recalled that Pound 'contrived to look "every inch a poet"': quoted in Cork 1976, p. 23. For an account of Pound's trajectory as a poet in London see Carpenter 1988, pp. 97–371.

31 Dismorr, 'June Night', in Lewis 1915, pp. 67–68. Dismorr's prose poem is both a documentary of a journey made by an independent female protagonist through the West End of London and an experiment in aesthetic form.

32 When recalling her friend Harriet Shaw Weaver at Vorticist dinners at Gennaro's restaurant, Saunders is quoted as saying: 'She was as silent in "company" as I was myself and I can't remember anything that either of us said!' (Lidderdale and Nicholson 1970, pp. 119–20). Saunders confessed to being 'solitary by nature' in a letter to Dismorr (Saunders 1917). Peppin has pointed out that, whilst Saunders may have been socially reticent, she was confident in her core identity as an artist. Saunders's very attendance at Vorticist and Imagist dinners is testament to this. It is also highly significant that in 1914 Saunders's name was included in an announcement in *The Egoist* of a subsequently unrealised project to establish a 'College of Arts' in London, designed to attract American students to the capital – a project promoted by Ezra Pound. 'H. Sanders' is listed in the 'Painting' category as 'Assistant, and Director of the Atelier', with Wyndham Lewis's name listed alongside 'Atelier of Painting': see *The Egoist,* 2 November 1914, pp. 413–14. Saunders's inclusion as a primary figure for this ambitious venture adds further weight to arguments for her importance as an artist, and for her commitment to the Vorticist cause.

33 It is unclear if money ever changed hands between Stulik and Lewis; see O'Keeffe 2000, pp. 172–73. However, it is notable that in 1919, when William Roberts was commissioned by Stulik to create murals for the restaurant, payment took the form of free and regular meals at the establishment: see Cork 1985, p. 239.

34 For a detailed discussion of the Cave of the Golden Calf see Cork 1985, pp. 61–115, and, more recently, Cottrell 2019, pp. 86–101.

35 Though others were involved, the primary group of artists that created the decorations for the cabaret project included Lewis, Spencer Gore, Charles Ginner, Jacob Epstein and Eric Gill (see Cork 1985, pp. 66–67). On 27 June 1912 the *Music Hall and Theatre Review* reported that 'other artists propose adding pictures to the walls of the cave' (p. 11).

36 Saunders's subject and choice of palette in *Cabaret* may have been directly influenced by the various descriptions of the club carried in press reports of 1913, though it also allows for speculation that Saunders may have enjoyed the musical entertainments first hand. The *Pall Mall Gazette* recorded that 'Evidently colour dominates at the Cabaret in every way. The waiters will be costumed as Neapolitans. The negro orchestra is clad in crude green and crimson silks, resembling gorgeous figures by Tiepolo': see 'The Cabaret Club', *Pall Mall Gazette,* 29 September 1913, p. 13. In the 1930s *The Tatler* recorded that Strindberg

introduced to her cabaret the American string band 'The Versatile Three', one of the first small groups of African-American musicians to tour to Britain and Europe, and according to the report as a result 'syncopated music became all the rage': 'The Passing Pageant 1910–1920', *The Tatler*, 1 May 1935, pp. 32–33.

37 Richard Cork uses the phrase 'his allies', suggesting that a collaborative approach was taken for the projects Lewis was commissioned to deliver. These included a commission to decorate dining rooms for Mary Borden Turner, a wealthy American painter, novelist and suffragist, in her house on Park Lane. This project was unfulfilled (see Cork 1976, p. 270; also O'Keeffe 2000, pp. 167–71). Lewis was also commissioned to decorate a dining room in Lady Drogheda's house in Belgravia (Cork 1976, p. 270; O'Keeffe 2000, p. 145). Literary hostess Violet Hunt asked Lewis to transform her partner Ford Madox Ford's study at South Lodge, which Goldring remembered as 'a large abstract decoration' (see Goldring 1943, p. 13). Rebecca West later described the scheme as 'very violent and explosive' (see Cork 1976, p. 270).

38 Cork 1985, p. 229. Both artists were barely twenty at the time.

39 Cork 1985, p. 229.

40 William Roberts, *Abstract & Cubist Paintings & Drawings*, p. 7, quoted in Cork 1985, p. 221.

41 The artist Harry Jonas recalled that some of the decorations seemed to have been 'directly done on the walls': Cork 1985, p. 221.

42 'Restaurant Art', *Colour*, April 1916, p. xiv, quoted in Cork 1985, p. 220.

43 Cork 1985, p. 230.

44 Cork 1985, p. 221.

45 Ibid.

46 'The Vorticists. Perils of a West End Restaurant', *Pall Mall Gazette*, 15 January 1916, p. 3.

47 Ibid.

48 Ibid.

49 Ibid.

50 Ibid.

51 *Daily Mirror*, 18 January 1916, p. 2.

52 Despite his extensive research conducted in the British Newspaper Library and elsewhere proving fruitless, Richard Cork expressed hope that photographs of the 'Vorticist Room' might be found one day: Cork 1985, pp. 219 and 313 n.27.

53 *Pall Mall Gazette*, 15 January 1916, p. 3.

54 I am grateful to Brigid Peppin for her generous insights shared during our many fruitful, and ongoing, discussions about the nature of the decorations at the Tour Eiffel restaurant.

55 Edwards 1994, pp. 34–38. Edwards provides a detailed discussion of *Red Duet* in Edwards 2000b, pp. 167–97.

56 For a discussion on the Vorticist exhibition at the Doré Galleries see Gruetzner Robins 2011, pp. 59–65.

57 See Lewis 1915, p. 63.

58 The 'Vorticist Evening' took place on 23 February 1916 (Cork 1985, p. 236).

59 Chipkin and Kohn 2020.

60 For the colour reconstruction of Helen Saunders's *Atlantic City* see the forthcoming publication by Chipkin and Kohn. A painted portion of the reproduction will be exhibited in the Courtauld Project Space as part of a small display focused on the rediscovery in October 2022.

61 Cork 1985, p. 221.

62 Ibid.

63 Ibid.

64 Cork 1985, p. 220.

65 Ibid.

66 A recent visit to the premises allowed for some measuring of the current first floor room. If the room was partitioned to accommodate the two windows to the left of the building (looking from street level) the estimated dimensions of the Vorticist Room would have been approximately 6 × 5.2 metres. There is evidence in the room to suggest that a partition existed as described here.

67 This information is reported in the *Belfast Telegraph* of 10 August 1937, p. 6.

68 Cork 1985, p. 229.

69 Richard Warren discusses the orientation of *Monochrome Abstract Design* (https://richardawarren.wordpress.com/helen-saunders-a-little-gallery; last accessed 11 March 2022).

70 Beckett and Cherry 2000, p. 64.

71 Paul Edwards, in Edwards 2000a, p. 119.

72 Cork 1985, p. 229.

73 Saunders came from a comfortable middle-class background, whilst Lewis was dogged by financial worries throughout his life. See Peppin 1996, p. 14. Peppin also cites the deliberate misspelling of Saunders's name in *BLAST* as further evidence of her reticence to be named publicly.

74 Peppin 1996, p. 24 n.59.

75 Lewis enlisted in March 1916 (Edwards 2000b, p. 167).

76 William Roberts, 'Cometism and Vorticism: A Tate Gallery Catalogue Revised', *Vortex Pamphlet* no.2, reproduced at 'The English Cubist' (http://www.englishcubist.co.uk/cometism.html; accessed 14 September 2020). Roberts refers to *BLAST* retrospectively as 'this chubby, rosy, problem-child BLAST'.

77 Cork 1985, p. 313 n. 50.

78 Ethel Saunders worked as a VAD nurse in France during the latter part of the war. Correspondence between Ethel and her mother during this period survives in a private collection. In one letter dated 8 July 1918 Ethel Saunders comments upon 'futurist' décor that she witnessed in the WAAC club in Rouen, suggesting that she was familiar with avant-garde art at the time, possibly inspired by her knowledge of the Tour Eiffel decorations. I am indebted to Brigid Peppin for sharing this information and these valuable insights with me.

Detail of cat. 10

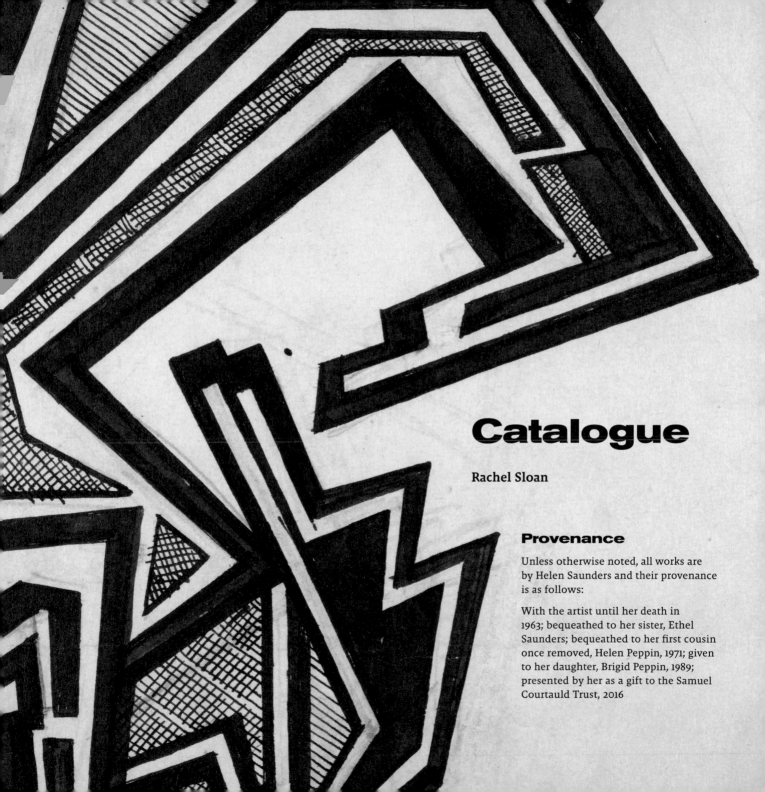

Catalogue

Rachel Sloan

Provenance

Unless otherwise noted, all works are by Helen Saunders and their provenance is as follows:

With the artist until her death in 1963; bequeathed to her sister, Ethel Saunders; bequeathed to her first cousin once removed, Helen Peppin, 1971; given to her daughter, Brigid Peppin, 1989; presented by her as a gift to the Samuel Courtauld Trust, 2016

1
Tree, c. 1913

Graphite, black ink and watercolour on wove
paper, with multiple pinholes at all four corners
and upper and lower centre edges, 353 × 254 mm
Verso: inscribed 3 (upper right, graphite)
The Courtauld, London (Samuel Courtauld Trust),
D.2016.XX.8

Exhibitions Oxford and Sheffield 1996, no. 2

Literature Peppin 1996, p. 43; Foster 2019, p. 34

Apparently made around the same time as *Canal* (cat. 2), this drawing shows Saunders applying her signature techniques of simplification and abstraction to a single motif. A single tree fills most of the sheet, its foliage described in discrete blocks of different shades of green and blue-green, with shadows suggested by streaks of darker watercolour. The foliage appears to have been peeled away in the front to reveal the trunk and branches, rendered as a tubular grey bole sprouting spiky limbs. Its setting is subtly hinted at by the diagonal line that crosses the lower foreground – perhaps the border of a lawn or the kerb of a suburban street. However, Saunders's treatment of the tree is anything but conventional and reveals her to be a keen student of recent developments in French painting. The tubular trunk recalls the trees of Henri 'Le Douanier' Rousseau, that earlier poet of the suburban strange, and the abstracting approach and flattened perspective appears to look to several Fauve painters, particularly Henri Matisse, whose painting *The Conversation* (1908–12, St Petersburg, The State Hermitage Museum, inv. no. GE 6524), which Saunders would have seen at the Second Post-Impressionist Exhibition in 1912, features similarly flattened, schematic trees. Another possible influence may have been an artist closer to home, Spencer Gore, whose work she knew well.

The status of this drawing is ambiguous. Its large scale and high degree of finish – almost every inch of the sheet is covered – suggest an ambitious independent work, and the presence of numerous pinholes in all four corners of the sheet hints at a long generation. However, the presence of two sets of fingerprints along the left edge suggest a certain informality of treatment. Although there is no record of its having been exhibited, our lack of precise knowledge about which of Saunders's works were included in exhibitions means that this cannot necessarily be ruled out. It would not have looked out of place among the work of other artists in Roger Fry's orbit, either in London or in Paris.

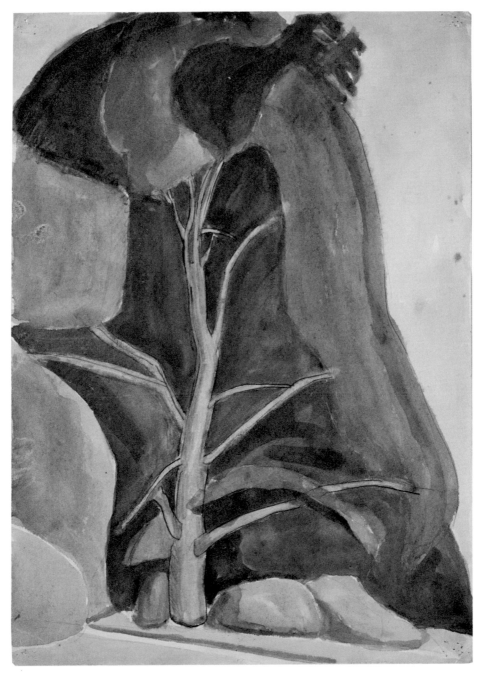

— not ot a city —nature

2
Canal, c. 1913

Graphite, pen and brown ink and brown wash, squared in graphite, on wove paper, with several pinholes at the corners, 434 × 340 mm
Verso: inscribed *Drawn by / Helen Saunders / Chelsea* = (lower right, graphite)
The Courtauld, London (Samuel Courtauld Trust), D.2016.XX.7

Exhibitions Oxford and Sheffield 1996, no. 3

Literature Peppin 1996, pp. 9, 43, illustrated p. 10

This large and ambitious ink drawing probably depicts a section of the Regent's Canal near King's Cross. Saunders would have been familiar with the area in part thanks to her friend and fellow artist Hubert Waley (1892–1968), who shared a studio in the area, near the Caledonian Market, with her artist cousin Reynolds Ball. In contrast to Waley's topographically accurate drawings and prints of the canal, Saunders's vision is boldly simplified. Most of the elements of the composition are treated as geometric solids; the spiky trees resemble enormous palms or cacti, and they and the buildings dwarf two tiny, block-like figures on the towpath, whose bodies seem to be bowed under a great weight. The tilting perspective and compression of middle ground and background, as demonstrated by the overlapping of the two bridges and of the left-hand tower and cloud, seem to reflect the influence of Rosa Waugh's concept of 'natural perspective' (see p. 9). The ink washes have been applied in varying levels of dilution, with the darkest, nearly black, reserved for the areas under the arches of the bridges, leaving a dark void at the centre of the composition that heightens the sense of threat. Although the inscription, in another hand, suggests that the work was exhibited as is, the squaring of the drawing in graphite raises the possibility that the artist may have had a larger, painted composition in mind.[1] Whether another version was ever made, however, remains unknown.

Saunders was not the only artist later to be associated with Vorticism to draw inspiration from the industrial surroundings of this stretch of the Regent's Canal around this period. Christopher Nevinson (1889–1946), a member of the Rebel Art Centre who later fell out with Wyndham Lewis over his alliance with the Italian Futurist Filippo Tommaso Marinetti and was consequently excluded from the Vorticists, painted a similar view, *The Towpath* (Oxford, Ashmolean Museum, inv. no. WA1937.80) in 1912. Although it also conveys a sense of the figures being menaced by their surroundings, with its Divisionist-style facture, meticulous detailing of the buildings and one-point perspective it feels decidedly conventional alongside Saunders's bold and unsettling drawing, whose almost abstract treatment of the figures, the railway lines and signals appears to presage aspects of her Vorticist work.

└yes – interested in city already

1 The fact that the inscription is in another hand raises the possibility that it may have been exhibited (that is, that the inscription was added by an exhibition organiser). The hand has not been identified, but it bears some resemblance to Katie Gliddon's; I am grateful to Brigid Peppin for this suggestion.

—ot a city female + male figure, ambiguous

3a
Mother and child with elephant (1), c. 1914–22

Graphite, pen and brown ink and brown wash on wove paper, laid down, 445 × 287 mm
The Courtauld, London (Samuel Courtauld Trust), D.2016.XX.14

Literature Peppin 1996, pp. 15 and 48

3b
Mother and child with elephant (2), c. 1914–22

Graphite, pen and brown ink and brown wash on wove paper, laid down, 447 × 287 mm
The Courtauld, London (Samuel Courtauld Trust), D.2016.XX.15

Exhibitions Oxford and Sheffield 1996, no. 23

Literature Peppin 1996, pp. 15 and 48

Not exhibited

These two closely related drawings were almost certainly made during a single sitting; both depict the same models with only minor variations to the pose and appear to have been done on paper from the same source.[2] Yet the treatment of the figures differs markedly: while both sheets display the same tendency to simplify and abstract, the mother and child in cat. 3a are depicted in a more naturalistic and detailed manner, and an attempt has been made to ground them in a specific setting by way of the lightly sketched chair on which the woman sits. The second drawing is noticeably more schematic, the blocky figure of the mother, with her almost cartoonish features, rendered as an assemblage of geometrical shapes unanchored in space and the shadows on her arm and the child's head laid on with bold streaks of wash.

Uncertainty regarding these drawings' date means that they occupy an ambiguous position in Saunders's surviving oeuvre. The wooden elephant that the mother holds indicates that the drawings are unlikely to date from before late 1914, as this toy was probably made in the factory set up in the East End by Sylvia Pankhurst to provide work for women left unemployed by the war.[3] However, they may have been made at any point between then and around 1920; the woman's dress and hairstyle appear to be of the late 1910s or early 1920s, although the lack of detail makes this difficult to ascertain.[4] This ambiguity raises two equally intriguing possibilities. If Saunders made the drawings during her Vorticist period (1914–15) they might be read either as an attempt to apply the principles of Vorticism to the human figure or as an indication that, even when her work was at its most radical, she never entirely abandoned figuration. If, however, as seems more likely, the drawings were made later, they may offer early evidence of a renewed interest in figuration and the path her work would take in the post-war years.[5]

2 Brigid Peppin speculates that cat. 3b was made first and the more representational drawing, cat. 3a, was made second, after the child had fallen asleep, as this would have allowed Saunders greater scope for capturing detail (Peppin 1996, p. 25, n. 71).
3 This is corroborated by an early photograph of the factory, which shows an elephant similar to that depicted in the drawings (Peppin 1996, p. 48).
4 I am grateful to Rebecca Arnold and Beatrice Behlen for their comments on the date of the woman's attire and hairstyle.
5 Saunders made very little, or possibly no, artwork during the last two years of the war, during which she was not only employed full-time in a government office but also acted as an unpaid secretary to Wyndham Lewis. The only creative work she is thought with any certainty to have produced in these years is poems, although they cannot be dated with great precision.

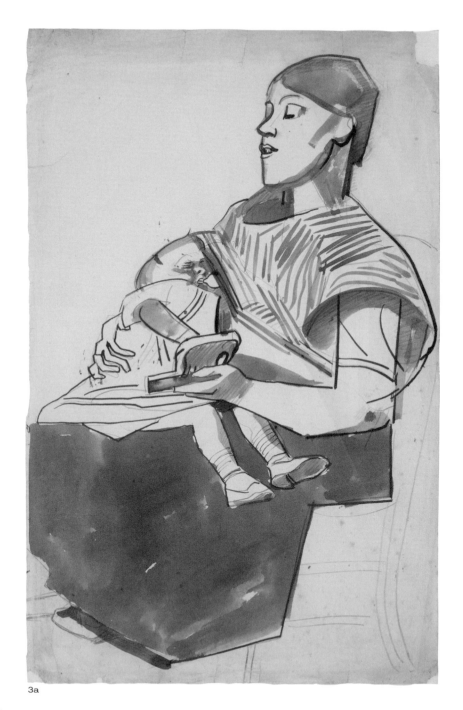

3a

not really god, but <u>nones</u>

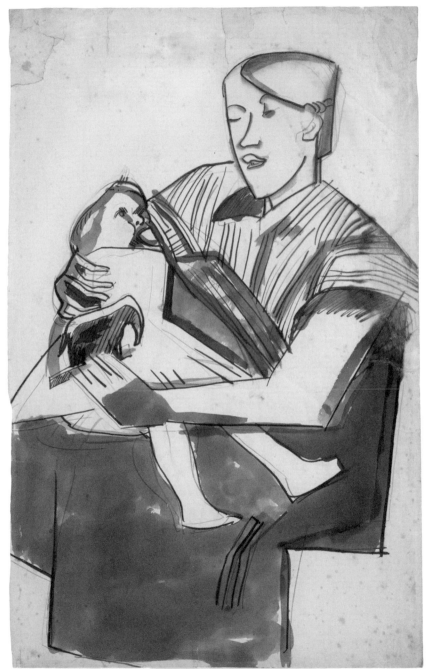

3b

4
Portrait of a woman, c. 1913

Graphite and watercolour on wove paper, with pinholes at each corner and the lower centre edge, 352 × 271 mm
The Courtauld, London (Samuel Courtauld Trust), D.2016.XX.9

Exhibitions Oxford and Sheffield 1996, no. 4

Literature Peppin 1996, p. 44

Blanche Caudwell (1880–1950) had been a friend of Saunders since about 1908, and would share a flat with her from 1933 until her death. After her retirement in 1940 she would become Saunders's most frequent sitter.[6] The present drawing, one of her earliest portraits of Caudwell, may relate to a *Portrait of a Woman* (present whereabouts unknown) included in the 'Twentieth Century Art' exhibition at the Whitechapel Gallery in June 1914. With great economy, Saunders captured her sitter's distinctive physiognomy – a long face with prominent jaw and cheekbones, a strong nose and large, heavy eyelids – and typically impassive expression, at the same time as she stripped away naturalistic detail in favour of stark stylisation. Although ostensibly a study, the handling is confident and decisive; the only hints of correction or hesitation occur in the doubled outline of the nose and a slight pentimento in the chin. The planes of the face and neck are modelled with broad strokes of wash, reinforced with rapid parallel hatching; those areas left bare of wash appear flooded with light.

Saunders's work had been described as 'Cubist' in 1913, a characterisation that applies with particular justice to this drawing.[7] Blanche's face is abstracted and broken down into discrete planes that, recombined, complicate the boundaries between two- and three-dimensionality. Saunders was certainly aware of the work of Pablo Picasso and Georges Braque, and this portrait seems to acknowledge, if not directly respond to, the numerous painted and sculpted portraits Picasso made of his companion Fernande Olivier during the summer and autumn of 1909. The portraits of Olivier are now generally considered to be among the very earliest Cubist works and a vital stepping stone on the journey toward the full-blown Analytical Cubism that Picasso and Braque developed the following year. *Portrait of a woman* seems to occupy a similar place as a transitional work in Saunders's surviving oeuvre.

6 Although the relationship between Saunders and Caudwell was longstanding, it is unlikely to have been romantic. They probably shared a flat at least in part for financial reasons; Brigid Peppin recalls her mother remarking after Caudwell's death that Saunders would need to find a smaller, cheaper flat.

7 Cork 1976, chapter 7, n.25, records that this comment was written in the margin of the Tate Gallery Library's copy of the 1913 AAA catalogue. The annotator is thought to have been the deaf artist John Doman Turner (1871–1938).

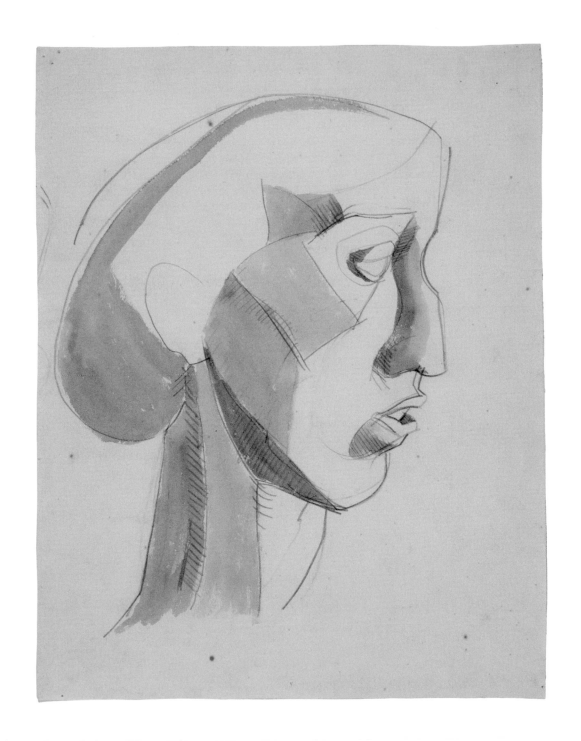

5
Untitled ('The Rock Driller'), c. 1913

Traces of graphite, black ink (with added oil?) and bodycolour on wove paper, 99 × 132 mm
The Courtauld, London (Samuel Courtauld Trust), D.2016.XX.10

Exhibitions Oxford and Sheffield 1996, no. 7

Literature Cork 1976, p. 151; Peppin 1996, pp. 12 and 44; Hickman 2013, p. 133

This drawing exhibits a dynamism and formal boldness that belies its diminutive scale. Two figures occupy a landscape rendered in bands of strong colour delineated by thick lines of black ink: at right, a green-skinned nude figure wearing what appears to be a striped headdress is hunched over a rock drill that gouges huge splinters out of the ground and throws up a plume of dust; at left, another nude figure, pink-skinned and grinning, dances with Dionysiac abandon.[8] The radically anti-naturalistic approach to the human figure and the combination of vivid colour and heavy outlines, reminiscent of stained glass, are found in other surviving drawings from 1913–14 (see cat. 6 and 7) and seem to mark a transitional phase between Saunders's earlier work and the Vorticism to come.

The title 'The Rock Driller' was given retrospectively, but both it and the right-hand figure inevitably suggest comparisons with Jacob Epstein's sculpture of almost the same name, the original version of which was begun in 1913, and of which Saunders was surely aware. Epstein's *Rock Drill*, in its first iteration, was a celebration of virility and the power of the machine, fusing a fearsome robotic figure with a real drill. Although the brutish rock driller in Saunders's drawing does seem to quote Epstein's, the female figure appears wholly different in mood, pose and lack of mechanical attributes. As Miranda Hickman notes, she serves as a colourful and joyous counterbalance to the grimly mechanistic driller and can perhaps be seen as a sly feminist riposte to the machine-worship of many of the male artists who would later come together under the banner of Vorticism.[9]

8 Miranda Hickman interprets the yellowish-green form between the figures of the rock driller and the dancer as another dancing figure (Hickman 2013, p. 133); however, upon close examination of the drawing this seems more likely to be a cloud of smoke or dust thrown up by the drill rather than a figure. This may be an instance of intentional ambiguity, which is not unusual in Saunders's work; see for example cat. 13.

9 Ibid. The sphinx-like nature of the *Rock Driller* has been connected by Alan Munton to Epstein's Tomb for Oscar Wilde (Munton 2006, pp. 78–79). Jo Cottrell has noted that Epstein was also working on his 'caryatid' sculptures for the Cave of the Golden Calf during this period, which leads her to speculate on a possible reference to the cabaret here. Brigid Peppin has also suggested that the drawing may express sexual anxiety; it is possible that Wyndham Lewis may have made advances to Saunders around this time, which she probably resisted.

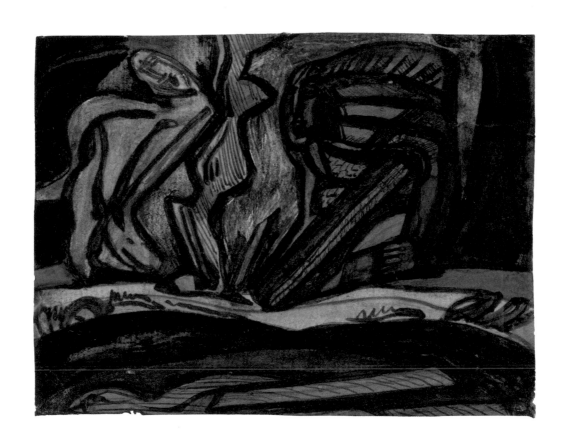

Ambiguous gender of figures

nature/figure
- not city, Δ in style though

6
Hammock, c. 1913–14

Graphite, brown ink and watercolour on wove paper, the lower left corner made up on laid paper, 355 × 414 mm
Verso: inscribed *Imp* (upper left, graphite); inscribed *ROT. No. 5* (lower left, graphite)
The Courtauld, London (Samuel Courtauld Trust), D.2016.XX.12

Exhibitions Oxford and Sheffield 1996, no. 6; London 1997, no. 175; London 2014, no. 28

Literature Peppin 1996, pp. 10–11 and 44; Hickman 2013, p. 126

The vibrant colour and strong black outlines of *Untitled ('The Rock Driller')* (cat. 5) also characterise this larger and more ambitious, yet not entirely resolved, composition.[10] A nude woman, her face resembling a carved mask, lies in a hammock that appears to be strung above a dark blue pool. Far from being an image of indolence or sensuality, her attitude and expression suggest extreme physical and emotional suffering. The hammock resembles a winding sheet or shroud, and the figure's hands, with their twisted, tortured fingers, have been likened to those of Christ in Matthias Grünewald's *Crucifixions*.[11]

Like *Portrait of a woman* (cat. 4), *Hammock* seems to nod to the somewhat earlier work of Picasso and Braque – specifically, here, to Picasso's treatment of the female nude around 1907–08 in paintings such as the notorious *Demoiselles d'Avignon*. However, the nude's face – despite its masklike quality – is far more expressive than those of Picasso's stolid figures, and the setting hints at a feminist reading totally removed from anything in his oeuvre. Brigid Peppin has noted the resemblance of the framework from which the hammock is strung to the back of a Queen Anne chair, a piece of furniture common in comfortable middle-class British homes at the turn of the century – that is, the type of home in which Saunders had grown up but had recently left.[12] This suggests that the woman in the hammock is being torn between conventional middle-class respectability and the freedom and expressive possibilities offered by the bohemian milieu implied by this drawing's avant-garde approach. Saunders herself had left the comfort of her family's home for a more straitened, but independent existence around the time of the drawing's creation, but during the most radical period of her career sought partial anonymity to spare the more conventionally minded members of her extended family embarrassment. She would therefore have been keenly aware of the personal significance of this dilemma faced by numerous women artists.

10 Despite its large scale, the lack of resolution as well as the emotional turmoil expressed by the figure suggest that this was an essentially private work, never exhibited; it cannot be connected with any of Saunders's work that was known to have been shown publicly.
11 The comparison was first drawn by Peppin 1996, p. 10; pertinent examples in Grünewald's oeuvre include the *Crucifixion* panels of the Isenheim and Tauberbischofsheim altarpieces, both of which were in public collections by this date.
12 Cited in Hickman 2013, p. 126.

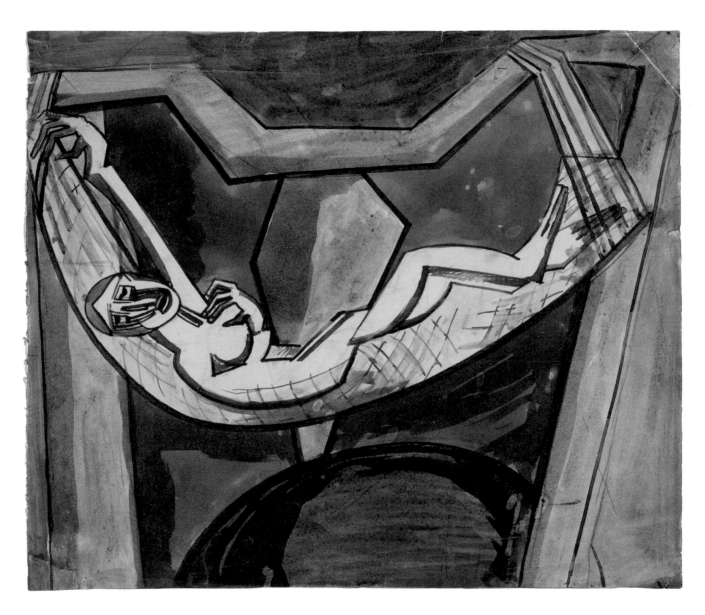

Clooks ambiguous — maybe breasts but
would looks more?

7

Untitled ('Female figures imprisoned'), c. 1913

Black ink, watercolour and bodycolour on laid paper; some strokes of watercolour on the verso, 158 × 196 mm
Verso: inscribed *1* (upper left corner, graphite, circled); inscribed with an arrow pointing up (upper centre, graphite); inscribed *51* (lower right, graphite)
The Courtauld, London (Samuel Courtauld Trust), D.2016.XX.11

Exhibitions Oxford and Sheffield 1996, no. 8; London 2017 (no catalogue); Chichester 2019, no. 20

Literature Cork 1976, p. 150; Tickner 1992, pp. 21–22; Peppin 1996, pp. 11 and 44; Hickman 2013, pp. 129 and 134; Foster 2019, pp. 33–34

This small, freely drawn watercolour depicts a group of seven figures with stylised, mask-like faces enclosed within an indeterminate but clearly confined space bounded by a heavy black line. The figures at right and left are clearly female; the gender of the others is ambiguous. What is not in doubt, though, is the pressure the enclosure appears to exert on the figures, whose spindly bodies appear compressed and deformed by their close quarters.

The title 'Female figures imprisoned' is modern and not Saunders's own. In spite of the ambiguous gender of several figures, some scholars have read this drawing as Saunders's most explicit commentary on contemporary debates about feminism, with Lisa Tickner arguing that here 'Saunders probably comes closer than anybody in the pre-war avant-garde to producing an overtly feminist painting'.[13] However, it has also been argued that the drawing may express a more general frustration with the strictures of middle-class respectability.[14] Saunders's personal sympathies with feminist debates and activism seem fairly clear, given her friendships with suffragists such as Katie Gliddon and Rosa Waugh Hobhouse and her participation in the 1911 WSPU Coronation Procession as well as an undated letter to Wyndham Lewis in which she seems wryly to critique the misogyny of Otto Weininger's influential *Sex and Character* (1903; English translation published 1906).[15]

Further complicating this reading is a parallel noted between the imagery of this drawing and that of 'The Cave', an undated poem which Saunders may have been written in the years immediately preceding Vorticism.[16] The poem imagines the cave as a space defined by 'concentrated narrowness' and 'walls [that] lean heavily' but also as a place of beauty, shelter from the 'brazen' sun and sea 'too glittering and wide', as a place of potential sanctuary and, perhaps, artistic creation. Miranda Hickman has noted similar imagery in Lewis's Vorticist writings as well as parallels between the present drawing, the poem, and the palette and formal vocabulary of Vorticist painting.[17] Such a reading does not necessarily negate a feminist interpretation of this drawing; rather, it grounds such concerns firmly within the context of Vorticism, in which Saunders found escape from the constraints of conventional femininity.

13 Tickner 1992, p. 22.
14 Peppin 1996, p. 44.
15 Ibid., p. 11.
16 Reproduced in Peppin 1996, p. 35. Although 'The Cave' is likely to date to around 1913–14, it is important to note that some of Saunders's poetry may have been written in the later years of World War I (c. 1916–17). If the poem post-dates the drawing, this raises the possibility of the drawing inspiring the poem.
17 Hickman 2013, pp. 130–31.

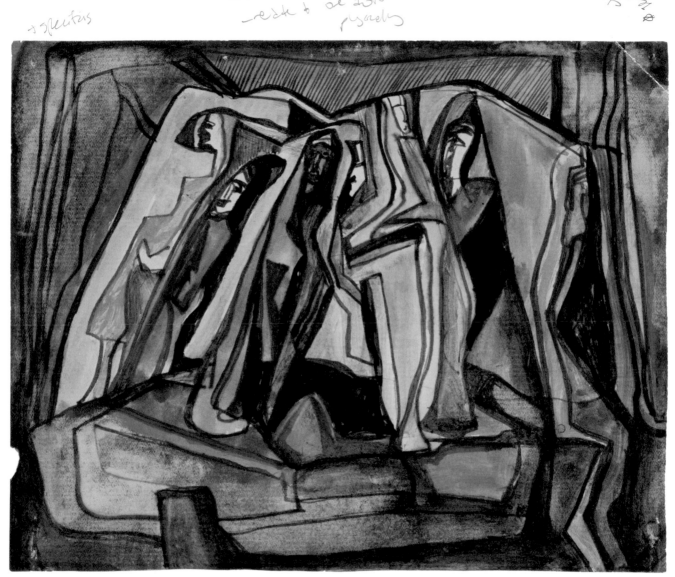

- body explored

- specifics

- figures don
- identifying artists
- relate to one another physically

- not contained by

- female figures - wearing clothes
- gender + femininity

8
Vorticist study with bending figure, c. 1914

Graphite and watercolour on wove paper, cut
into an irregular seven-sided shape, with multiple
pinholes at five of the corners, 250 × 342 mm
(irregular)
The Courtauld, London (Samuel Courtauld Trust),
D.2016.XX.13

Exhibitions Oxford and Sheffield 1996, no. 5;
Hanover and Munich 1996, no. 157; London 1997,
no. 176

Literature Cork 1976, p. 151; Peppin 1996, p. 44

Trimmed into an irregular heptagon by Saunders herself, this watercolour is one of her first surviving works to display the stylistic hallmarks of Vorticism. The palette is bright but largely restricted to the primary colours that would become associated with Vorticism. This angular trimming not only underscores the robotic qualities of the (apparently female) figure, whose blocky angularity is relieved only by a few streamlined curves, but also gives it the sense of being boxed in and inward-looking. The drawing seems to explore the interplay between the human body and the machine, an overriding concern of Vorticism.

The figure's ovoid head exhibits parallels with contemporary sculptures by Constantin Brâncuşi, notably *Sleeping Muse* (1910) and *Mademoiselle Pogany* (1912). Saunders was clearly aware of Brâncuşi's work, mentioning him by name in an unpublished poem in which she describes a barrage balloon as 'Brancusi's egg new risen from the ground'; an appended explanation notes that 'The Balloon is incidently [sic] the imagination in my vocabulary'.[18] This association of the balloon/egg with the imagination may offer some insight into the meaning of the figure's pose and gesture. The three bright red lines connecting the outsized hands hint at a musical or mathematical endeavour; Richard Cork has noted the similarities between the pose of Saunders's figure and William Blake's *Newton*, curled in upon himself as he measures the universe, and Brigid Peppin points out a possible allusion to George Frederic Watts's painting *Hope*.[19] Neither of these potential sources enjoyed wholly positive connotations at the time of the drawing's creation; Blake was well known to have detested Newton's 'single vision' and considered his scientific materialism sterile and empty, while the reputation of Watts, praised as 'England's Michelangelo' during his lifetime, suffered a steep decline with the advent of Modernism, *Hope* being regarded as a particularly egregious example of Victorian sentimentality.[20] Saunders's figure, with

18 Unpublished typescript, collection of Brigid Peppin. The date of the poem is uncertain and it may have been written later in World War I, when Saunders's only creative outlet was poetry. Incidentally, the collector John Quinn, who owned several of Brâncuşi's sculptures, also patronised Saunders; the three Saunders Vorticist drawings formerly in his collection (*Dance*, *Balance* and *Canon*) are now in the Smart Museum of Art, University of Chicago (see figs. 9 and 10).
19 A major exhibition of Blake's work was held at the Tate Gallery around the time this drawing was made (*Works by William Blake*, 15 October 1913–18 January 1914); it seems plausible that Saunders might have attended, particularly as she is known to have admired the artist.
20 *Hope* was widely known at the turn of the century thanks to the ubiquity of monochrome reproductions. If Saunders was indeed referencing it here, her purpose would surely have been to suggest the hopeless and moribund state of establishment culture.

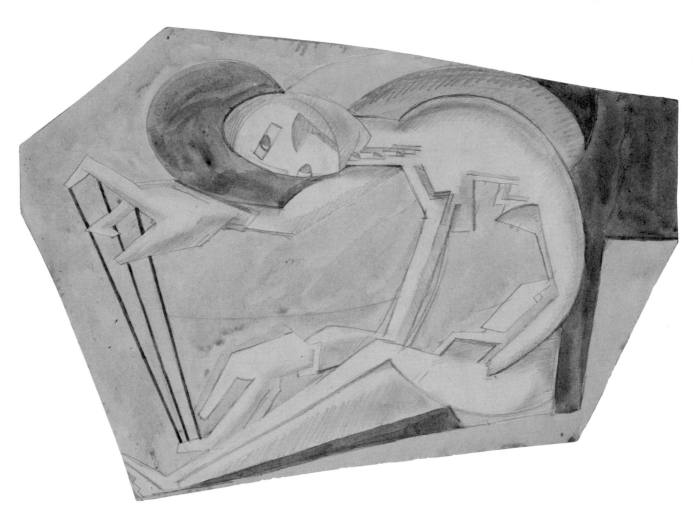

ambiguous gender

its egg-balloon head surrounded by a red halo or aureole, initially appears benign, but the massive hands with their claw-like fingers undercut the initial impression of harmlessness: are we looking at a benevolent but ineffectual being, obsessed with intellectual endeavour but hopelessly impractical, like the inhabitants of Laputa Saunders explored in the somewhat later Vorticist drawing *Island of Laputa*?[21] Or at a mechanical creation that, like a barrage balloon, stands ready to repel an aerial attack?

21 The prominence of geometric form and the act of measurement in the drawing may correspond to the Laputians' 'Ideas [which] are perpetually conversant in Lines and Figures. If they would, for Example, praise the Beauty of a Woman, or any other Animal, they describe it by Rhombs, Circles, Parallelograms, Ellipses, and other Geometrical Terms; or else by Words of Art drawn from Music'. Furthermore, Laputian tailors measured Gulliver's 'Altitude by a Quadrant, and then with Rule and Compasses, described the Dimensions and Outlines of my whole Body'. The figure's unusual appearance – head angled to the side and apparently exhibiting strabismus – also accords with Swift's description of the Laputians (Swift 1735, pp. 159–69). This potential allusion to *Gulliver's Travels* is especially intriguing in tandem with cat. 12, which may reference another episode of the novel.

9
Cabaret, c. 1913–14

Graphite, black ink and watercolour on wove paper, irregularly squared in graphite,
148 × 227 mm
The Courtauld, London (Samuel Courtauld Trust), D.2016.XX.5

Exhibitions Oxford and Sheffield 1996, no. 9; London 2014, no. 27; Cambridge 2015, no. 37; Chichester 2019, no. 21

Literature Peppin 1996, pp. 11–12 and 45; Foster 2019, pp. 34–35

This witty depiction of musicians in a cabaret fizzes with energy. Two double bass players, hybrid beings who appear to be part-human, part-instrument, occupy the centre of the composition, while a stalk-limbed conductor, his body deliberately truncated, directs them from the left. Two enormous spotlights, their light represented by the bare paper, illuminate the scene. Saunders's representation of electric light echoes Futurist imagery, but the anthropomorphic treatment of the double basses may harken back to an earlier source that might appear incongruous in the context of proto-Vorticism – Victorian nursery rhyme illustrations by Randolph Caldecott (*Hey Diddle Diddle and Baby Bunting*, 1882) and Walter Crane (*The Baby's Opera*, 1877).[22] The subject matter and Saunders's dynamic approach to it shows her keen interest in the syncopated rhythms of jazz, and the unconventional shapes of the popular dance that sprang up in its wake would inform a number of her surviving Vorticist works.[23] Indeed, this drawing may have been inspired by 'The Versatile Three' (sometimes known as 'The Versatile Four'), an African-American ragtime string band that performed in London and across Europe during this period.[24]

The drawing is squared up, albeit irregularly. Although it is not Saunders's only surviving drawing to exhibit squaring (see cat. 2 and 11), and in no case are they known to be preparatory for other works, in the present case the squaring is particularly intriguing. The subject of cabaret musicians performing has been linked with a London nightclub, Madame Strindberg's Cabaret Theatre, whose 'Cave of the Golden Calf' (1912–13) had been decorated by Wyndham Lewis, Spencer Gore and Charles Ginner and which was patronised by members of the avant-garde.[25] Saunders was not herself involved in the decoration but *Cabaret* raises the question of whether she might already have envisaged creating a decorative scheme for a similar space at this date – an ambition which would be fulfilled when she and Lewis collaborated on murals for the Restaurant de la Tour Eiffel in 1915.

22 Peppin 1996, p. 45. The cover of *The Baby's Opera* and one of the interior illustrations in *Hey Diddle Diddle* both feature an anthropomorphised dish and spoon, taken from the nursery rhyme 'Hey diddle diddle'. It is worth recalling in this context Frederick Etchells's disparaging remark that 'If Lewis had painted Kate Greenaway pictures, Saunders would have done them too' (Cork 1976, p. 419; Cork had interviewed Etchells in 1972). *Cabaret* refutes this retrospective slur in its co-opting of the twee imagery of Victorian children's books for radical ends.
23 See Brigid Peppin's essay in this volume, p. 9.
24 See Jo Cottrell's essay in this volume, p. 31. I am thankful to Jo Cottrell for drawing my attention to this band as a possible inspiration.
25 Peppin 1996, p. 12. Peppin also points out a slight similarity between *Cabaret* and Lewis's 1914 drawing *Circus Scene* (Michel 1971, cat. 160), which may relate to the graphics Lewis made for the Cabaret Club's promotional materials. Could *Cabaret* also have been intended as a promotional motif?

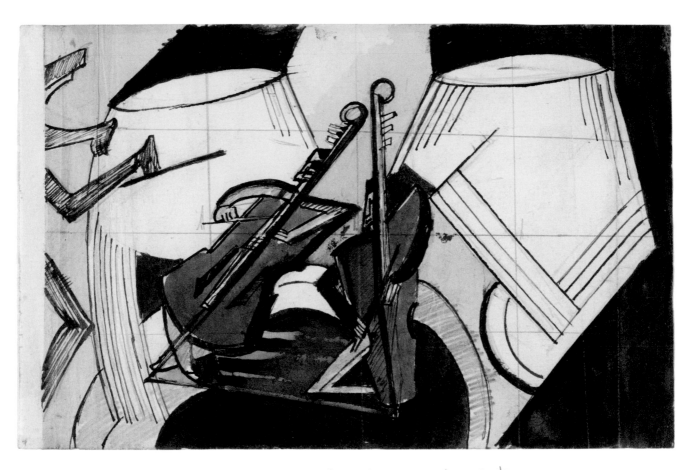

- figures hidden behind instruments
- ambiguous gender but possibly male

10

Vorticist composition, black and white [large], c. 1915

Graphite and black ink on wove paper,
305 × 230 mm
The Courtauld, London (Samuel Courtauld Trust),
D.2016.XX.19

Exhibitions Oxford and Sheffield 1996, no. 11;
Hanover and Munich 1996, no. 158; Preston 2020
(no catalogue)

Literature Peppin 1996, p. 45

This bold black and white composition is relatively unusual among Saunders's surviving Vorticist works in entirely eschewing figurative allusion. Composed entirely of sharp angles and straight lines, the drawing crackles with the jagged energy of a lightning bolt against the expanse of blank paper; most of the areas of white contained within the thick black lines are shaded with parallel hatching. Despite the overtly abstract approach, it is difficult to look at the drawing without trying to read some kind of representational image into it; the shapes curling around the void at centre call to mind a claw-shaped hand or the jaws of a fantastical beast, perhaps part-machine, about to crunch down on something. Given its creation during the early years of World War I, and the more explicit allusions to mechanised violence in other contemporary drawings by Saunders and her fellow Vorticists (see cat. 11 and 13), this may not be an unreasonable reading.

The ink stains to the left of the figure, and the numerous traces of partially erased graphite, point to the sheet's being a study or working drawing, and this design, and a related sheet now in the Tate collection (see fig. 28, p. 35), both relate to an uncredited tailpiece that appears on page 16 of the second (and final) volume of *BLAST* (July 1915) (see fig. 25, p. 31), which therefore can also be attributed to Saunders. In addition to the tailpiece, Saunders (her name misspelled as 'Sanders') contributed the poem 'A Vision of Mud' and the drawings *Island of Laputa* and *Atlantic City*. The pure abstraction of this design may also be connected to her work with Lewis on the murals they produced for the Restaurant de la Tour Eiffel the same year.

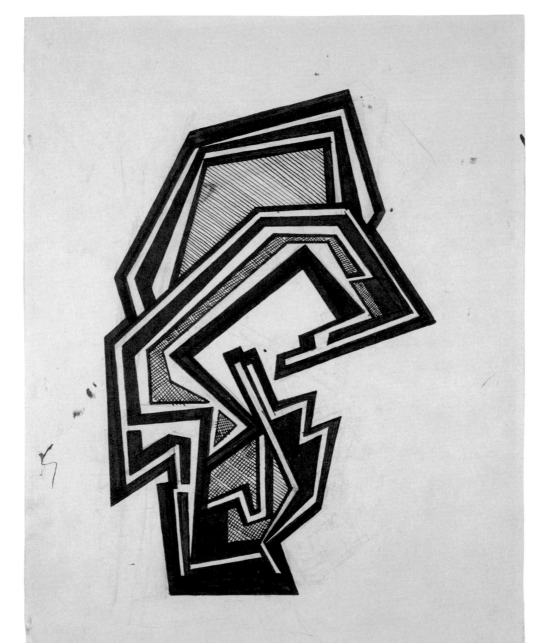

11

Vorticist composition with figures, black and white, c. 1915

Graphite and black ink on wove paper, squared in graphite, the central circle cut out from a separate sheet and glued down, 254 × 178 mm
Verso: inscribed with an arrow pointing up (upper centre, graphite)
The Courtauld, London (Samuel Courtauld Trust), D.2016.XX.18

Provenance With the artist until her death in 1963; bequeathed to her sister, Ethel Saunders; bequeathed to her first cousin once removed, Helen Peppin, 1971; given to her daughter, Brigid Peppin, 1989; presented by her as a gift and part-purchase to the Samuel Courtauld Trust, 2016

Exhibitions London 1974, no. 412; Oxford and Sheffield 1996, no. 13; Hanover and Munich 1996, no. 160; Durham, Venice and London 2010 (ex catalogue); Chichester 2019, no. 22; London 2021 (no catalogue)

Literature Peppin 1996, pp. 13–14 and 45; Foster 2019, p. 35

The attenuated angular forms that populate the lower half of this hard-edged monochrome drawing, despite their radical simplification, can easily be read as human figures, apparently trapped in a dark, confined space and set in frantic motion by, or around, the circular form at centre.[26] Drawn on a separate piece of paper pasted down on the sheet – probably one of the earliest examples of the collage technique in British Modernism – the circle draws the eye into the centre of the composition, a common Vorticist technique.[27] Its identity is unclear but full of menace – a black sun, a Cyclopean eye on a stalk, or the pendulum of an enormous machine. The identity of the blocky white forms posed atop the slope above the figures, and apparently bathed in light falling in stark, stylised stripes, is equally ambiguous, although their form and position seems to echo that of Michelangelo's figures of *Dawn* and *Dusk* and *Day* and *Night* on the Medici tombs.[28] It is unclear whether they are living beings or machines; it is equally ambiguous whether the figures below are at their mercy, crushed down, or in the process of rising up in revolt.

Brigid Peppin has noted the resemblance of the figures and their relationship to that of the Eloi and the Morlocks, the two post-human races depicted in H.G. Wells's 1895 novel *The Time Machine*. The relationship between the weak, effete Eloi and the underground-dwelling Morlocks, who labour to feed and clothe the Eloi but also, occasionally, eat one of their number, is presented as the logical outcome of the divide between the working and upper classes in turn-of-the-century Britain.[29] This conflict had as much resonance in 1915 as it did twenty years earlier and if Saunders were addressing it here that would accord with her sympathy with radical causes. However, the drawing's immediate context adds another layer to its interpretation. By 1915 the horrors of mechanised warfare were no secret; Saunders would have been particularly alive to this thanks to the pacifists and conscientious objectors in her immediate circle. This drawing, along with *Vorticist composition (Black and Khaki?)* (cat. 13) appear to be her most explicit responses to the violence of the First World War.

26 It is worth noting the resemblance between the figures in the present drawing and those in David Bomberg's somewhat earlier paintings *The Mud Bath* (1914, Tate, T00656) and *Vision of Ezekiel* (1912, Tate, T01197). Although Bomberg's work had major affinities with Vorticism, and Lewis invited him to join the group, he refused; however, his work was included in the 'invited to show' section of the Vorticists' sole London exhibition, at the Doré Galleries in 1915.
27 Saunders also used collage in the contemporary drawing *Island of Laputa* (Chicago, Smart Museum of Art, inv. no. 1974.275) as well as in cat. 13.
28 Peppin 1996, p. 45.
29 If this is the case, then another possible reading of the circle at the centre of the composition is as the tube through which the Morlocks ascended at night to harass the Eloi.

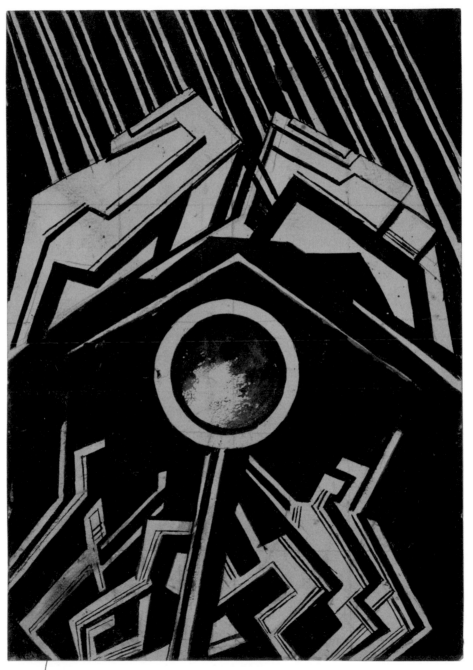

figures ce btelly non-gendered

12

Vorticist composition, yellow and green (formerly 'Gulliver in Lilliput'), c. 1915

Graphite, brown ink and bodycolour on wove paper, with pinholes at all four corners, laid down on cardboard, 308 × 368 mm
Recto: inscribed by the artist *H.S.* (lower right corner, grey ink); cardboard support, recto: inscribed *TOP.* (right centre, blue ballpoint, underlined) and inscribed *734.* (left centre, blue ballpoint)
The Courtauld, London (Samuel Courtauld Trust), D.2016.XX.17

Exhibitions London 1974, no. 408; Oxford and Sheffield 1996, no. 18; Hanover and Munich 1996, no. 165; London 1997, no. 178; Cambridge 2015, no. 36; Chichester 2019 (not in catalogue); Paris 2021 (no number)

Literature Peppin 1996, pp. 42 and 46

Saunders's considerable gifts as a colourist are on full display in this vibrant large-scale watercolour, painted with such vigour that brush hairs have been embedded in the paint layer. Interlocking planes of bright, unmodulated hues, dominated by an acid yellow-green, resolve into a faceless giant flexing its arms and curling its hands into fists as three tiny pink figures, resembling paper cutouts, appear to jump, leap and dive down the full length of its body. A colourful form resembling a sinister-looking mask lurks in the lower left corner. The drawing was for a time posthumously titled *Gulliver in Lilliput*, identifying the 'giant' as Lemuel Gulliver, the eponymous hero of *Gulliver's Travels*, captured in the midst of rupturing the bonds placed on him by the diminutive Lilliputians. If this was indeed the subject Saunders had in mind, there are interesting links to be made with another drawing made around 1915 with a title alluding to *Gulliver's Travels*; *Island of Laputa* (see fig. 5, p. 12) was published in the second issue of *BLAST*. It is important to remember, however, that the title was not Saunders's own and she may not have intended a direct reference to a specific literary source. Given the time of its creation, the drawing may allude more generally to the awakening of an unstoppable and potentially destructive force and human vulnerability before it; the field of yellow-green at the centre of the composition could also be read as a void, or as sulfurous flames, into which the small figures are plunging helplessly. It may also relate more broadly to the tension between conformity and liberation that runs through much of Saunders's work of this period, possibly representing a move away from the gendered conflict explored in cat. 6 and 7 towards a self-determined identity through the depiction of genderless bodies both free and yet still tethered.

The conflicting inscriptions on and surrounding the drawing hint at the difficulties posed by determining the correct orientation of Saunders's drawings, even those that, like the present work, are nominally figurative. The posthumous inscriptions in ballpoint on the mount indicate that at least one viewer thought its orientation was landscape. However, the presence of Saunders's initials in one corner appears to confirm what she considered the proper orientation – that is, with the giant figure upright. The drawing's size and degree of finish, as well as the inscription, raise the tantalising possibility that it may have been exhibited during Saunders's lifetime.[30]

30 It is, however, worth noting that none of the recorded titles of Saunders's exhibited works seem to fit this drawing.

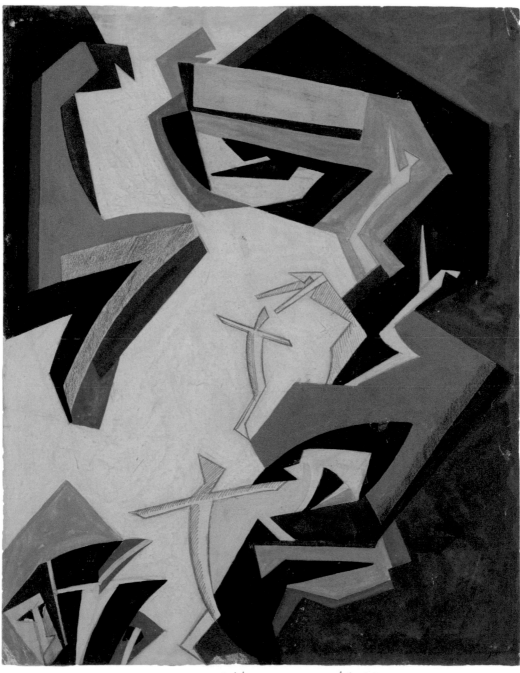

9/2006

-nude figures totally genderless

=freedom; abstic, —o easy dist

13
Vorticist composition (Black and Khaki?), c. 1915

Graphite, black ink, watercolour, bodycolour and collage (elements cut out from a separate sheet and superimposed) with scratching out on wove paper, with pinholes at all four corners, 373 × 278 mm
Inscribed by the artist *HS* (lower right, black ink)
The Courtauld, London (Samuel Courtauld Trust), D.2016.XX.16

Exhibitions London 1915 (?); Oxford and Sheffield 1996, no. 16; Hanover and Munich 1996, no. 163; London and Manchester 2004, no. 11; Paris 2021 (no number)

Literature Peppin 1996, pp. 33 and 46; Peppin 2010, pp. 592–93

In a shocking visual pun, a long-limbed, angular figure explodes from the mouth of a rifle, simultaneously victim and gunfire. Rendered primarily in pale flesh tones, the figure's knee, back, underarm and hand – imagined as a series of sharpening zigzags ending in a hooked claw – are painted in a pinkish red that evokes raw or bloodied skin; the sense of violence is further emphasised by the use of scratching out and rapid parallel hatching in graphite on the legs. This exploding figure is the brightest point in the composition, set against a background composed of geometric blocks of brown, yellow-brown, black and navy blue; the only brighter plane of background colour is a wedge of bright blue behind the figure, seeming to imply that the impact of the exploding figure has shattered a wall to reveal the sky beyond. Although this is not the only example of Saunders incorporating collage into her work (see cat. 11), it is almost certainly the boldest: most of the watercolour has been cut from one sheet, largely along the lines of the forms representing the explosion at lower right and upper left, and pasted down on another sheet covered in khaki wash, heightening the jagged edges and the sense of explosion and rupture. The centrality of the figure in this drawing highlights a key way in which Saunders's distinctive brand of Vorticism diverged from that of many of her fellow artists: she was concerned less with representing machinery and the urban environment and more with evoking the inhabitants of such environments and the way they responded to their surroundings.[31] In this instance the fact must be added that this drawing was produced in the teeth of war. The triumphal quality of the violence expressed in other, earlier Vorticist artworks, which carried a sense of destroying a hidebound old order, is here complicated by a knowledge of its human cost.

As with cat. 12, the high degree of finish and the presence of Saunders's initials in the lower right corner suggest that this drawing may have been exhibited during her lifetime. Indeed, one of the works she contributed to the Vorticists' sole London exhibition at the Doré Galleries in June 1915 was titled 'Black and Khaki', a title with military resonance that would seem to accord with the subject of this drawing, which may well have been the one displayed.[32]

31 Peppin 2010, p. 592.
32 The edges of the lower of the two sheets, in the areas painted brown, are in fact a greenish shade – khaki – which suggests that this was the original colour and it has faded with time, lending further credence to this theory.

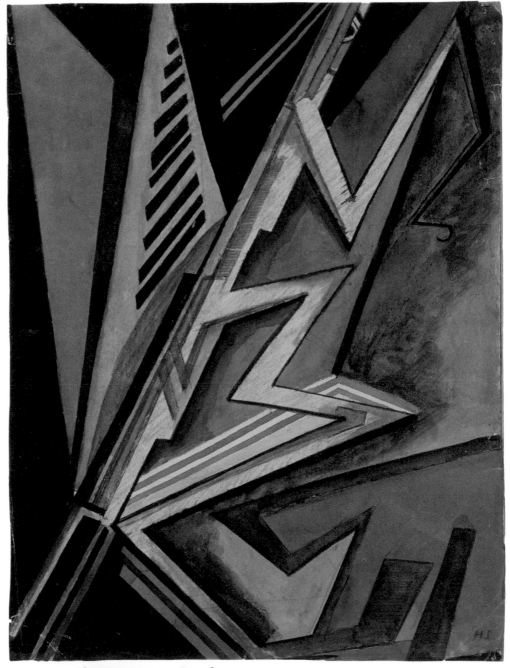

greets + was it
to its basesquard
-ols, re
ages leg

~ablaless figure

Ambiguity lor is it a (arm) (no~

14

Vorticist composition, blue and green, c. 1915

Graphite, black ink, watercolour and bodycolour on wove paper, 197 × 254 mm
The Courtauld, London (Samuel Courtauld Trust), D.2016.XX.20

Exhibitions London 1974, no. 410; Oxford and Sheffield 1996, no. 15; Hanover and Munich 1996, no. 162; Wolfsburg and Toulouse 2003, no. 16; Paris 2021 (no number)

Literature Peppin 1996, pp. 14 and 46

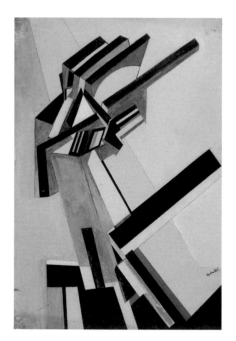

36 Wyndham Lewis, *Portrait of an Englishwoman*, 1913–14, graphite and bodycolour on paper, 560 × 380 mm. Wadsworth Atheneum Museum of Art, Hartford, CT, The Ella Gallup Sumner and Mary Catlin Sumner Collection Fund, 1949.457

Despite their embrace of abstraction, few of Saunders's Vorticist drawings are entirely non-figurative, making this drawing relatively unusual in her oeuvre.[33] The sheet, unevenly trimmed, is divided into vertical panels of yellow and green. Against this background emerges a form composed of multiple overlapping diagonal planes of black, white, grey, brown and varied shades of blue, appearing to project from the surface of the sheet. Although it is possible to read this form as a sort of machine emitting rays of light or energy (the bands of narrow black and white stripes), such a reading is highly subjective and may not accord with Saunders's intentions.

The similarities between the compositional structure of this drawing and that of Lewis's *Portrait of an Englishwoman* (fig. 36), published in the first issue of *BLAST*, have been noted, making this one of the only known instances of Lewis's direct influence on Saunders's Vorticist work.[34] However, several elements in the drawing complicate this reading by suggesting that Saunders may not have considered it a finished work. Unlike several of her large, highly worked Vorticist compositions, the sheet does not bear her initials.[35] Furthermore, numerous graphite lines are visible underneath, and sometimes on top of, the watercolour and bodycolour, particularly on the right side of the sheet; some appear partially erased, while others are undisturbed. Although traces of graphite are also visible in several of Saunders's signed Vorticist drawings, they are not as abundant as in the present drawing. This raises the possibility that she had not entirely finalised the composition, and might still have been experimenting. In any case, if Lewis's influence is indeed present, it is slight, giving the lie to Frederick Etchells's disdainful description of Saunders, many years after the end of Vorticism, as a slavish acolyte of Lewis.[36]

33 Only five such drawings, including the present one and cat. 10, are known (Peppin 1996, p. 14). This of course does not preclude the possibility of others, now lost, having existed.
34 Ibid.
35 See for example cat. 12 and 13, as well as *Canon*, *Dance* and *Balance* (Chicago, Smart Museum of Art) (see figs. 9 and 10)
36 See note 22 to cat. 9 above.

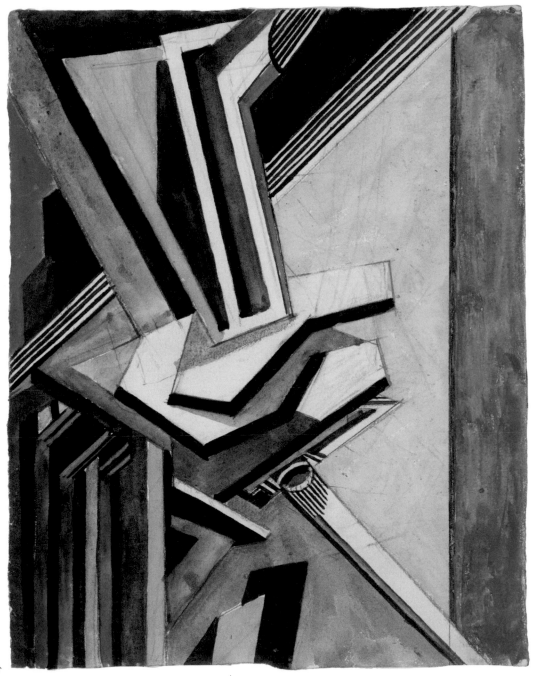

(similar to WL's portrait ot english woman)

15
View of L'Estaque,
c. 1920–29

Graphite and watercolour on wove paper, with multiple pinholes at all four corners and central edges, 383 × 296 mm
Verso: inscribed *G* (upper right, graphite)
The Courtauld, London (Samuel Courtauld Trust), D.2016.XX.21

Exhibitions Oxford and Sheffield 1996, no. 28

Literature Peppin 1996, p. 49

Seen from a road in what was then the eastern outskirts of the town, the centre of the Provençal town of L'Estaque appears hemmed in by the surrounding hills, in a view that is little changed today (fig. 37). A handful of cream-coloured houses, their clay-tiled roofs rendered in simple washes of ochre, cluster around a church. The ragged contours of the scrub-covered limestone hills have been streamlined, the hills broadly brushed in muted shades of blue and grey. The middle ground and background appear compressed into a single plane.

Saunders made at least one painting trip to the south of France during the 1920s, possibly (but not necessarily) in the company of her friend and former fellow Vorticist Jessica Dismorr. The present watercolour is one of a small group that survives from a period during which she renewed her commitment to figuration and, specifically, to landscape. Although in some respects it appears to hark back to her earlier work – the perspective and compression of the picture space recall Rosa Waugh's lessons in 'natural perspective', as also seen in cat. 2 – it also represents a new step in the evolution of her style. The blazing colour of her Vorticist period has been replaced by softer, muted tones, but the same impulse to abstraction that runs through her entire oeuvre is in evidence here; the hard-edged geometry that underpinned her earlier work remains, albeit tempered.

Another, almost identical version of the composition is now in the collection of the Ashmolean Museum (see fig. 11, p. 19); this, in tandem with the multiple pinholes in the corners of the present work, which suggest that it was worked on over several sessions, hint that it was likely to have been made in the studio rather than in front of the motif, perhaps based on an on-the-spot pencil sketch (see cat. 17a and b).

37 View of L'Estaque, 1995
(photograph: David Curtis)

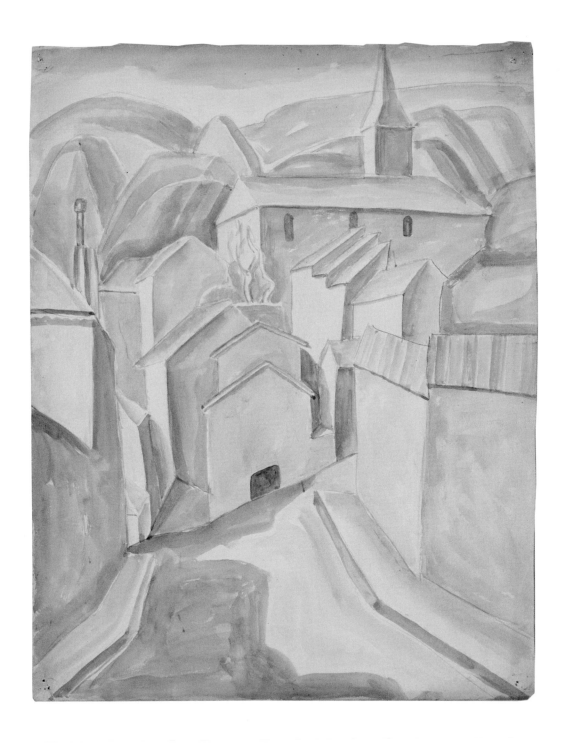

16
Cézanne's House, L'Estaque, c. 1920–29

Graphite and watercolour on wove paper, with pinholes at lower left corner and evidence that others at upper right corner have been trimmed away, 363 × 291 mm
The Courtauld, London (Samuel Courtauld Trust), D.2016.XX.25

Exhibitions Oxford and Sheffield 1996, no. 31

Literature Peppin 1996, pp. 18 and 49

38 Cézanne's house, L'Estaque, 1995
(photograph: David Curtis)

Sharply cropped by the top and left edges of the sheet, the façade of a house is further hemmed in by a low stone-topped wall that borders the street and forms one side of a staircase. The flattened picture plane and restricted palette of ochres and pinks give rise to the impression that the neighbouring buildings, in reality some distance away, also butt up against the house's right edge. The almost monochrome palette also focuses attention on the jigsaw of interlocking geometric planes formed by the buildings, their rectilinearity relieved only by the mass of foliage in the background and the curving limbs of the tree standing directly in front of the house.

This rather ordinary-looking house, which is still extant (fig. 38), was rented from the 1860s by Anne Elisabeth Honorine Cézanne, née Aubert; her son, Paul Cézanne, stayed there during his numerous visits to L'Estaque in the 1870s and 1880s, where he produced some of his most groundbreaking work. In selecting L'Estaque – a semi-industrial village on the outskirts of Marseille and not an obviously picturesque locale – as a subject, Saunders seems to have been guided less by its aesthetic possibilities than by her admiration for Cézanne, both as an artist and as someone she is likely to have regarded as a fellow 'solitary by nature'.[37] At the same time it is worth noting that, to judge by her surviving drawings, Saunders did not deliberately seek out the same vistas and landmarks the older artist depicted. In choosing to paint his house rather than one of his pictorial subjects, she may have been simultaneously paying homage to Cézanne whilst pursuing her own agenda, which was inspired by rather than indebted to his.[38]

37 See Brigid Peppin's essay in this volume, p. 18.
38 See Peppin 1996, p. 49. It is especially interesting to note that, in the present case, Saunders's sharp focus on the house excludes its panoramic view over the town and sea, which Cézanne famously depicted in *Red Roofs at L'Estaque* (1883, private collection).

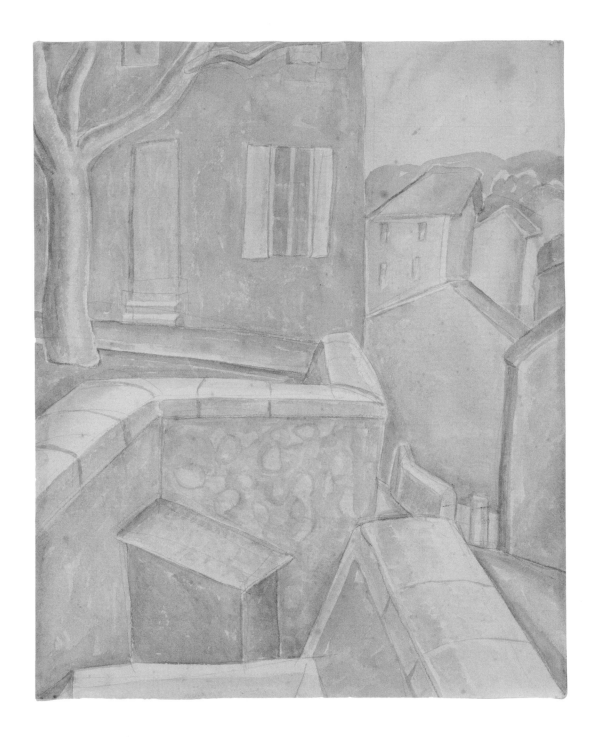

17a
Cement factory at L'Estaque (2), c. 1920–29

Graphite on wove paper, the left edge perforated as torn from a notebook, 331 × 259 mm
The Courtauld, London (Samuel Courtauld Trust), D.2016.XX.24

Exhibitions Oxford and Sheffield 1996, no. 30

Literature Peppin 1996, pp. 18 and 49

17b
Cement factory at L'Estaque (1) (recto); sketch of a road leading to a church (verso), c. 1920–29

Graphite and watercolour (recto), graphite (verso), on wove paper, with multiple pinholes at three corners (not upper left), 384 × 291 mm
Recto: inscribed [arrow pointing up] *meant just above line. Do not trim* (lower centre, graphite)
Verso: inscribed *c.* (upper right corner, graphite)
The Courtauld, London (Samuel Courtauld Trust), D.2016.XX.23

Exhibitions Oxford and Sheffield 1996, no. 29

Literature Peppin 1996, pp. 18 and 49

Observed from a promontory opposite, the buildings of the Lafarge cement factory appear to rise vertically up a steep slope. The limestone ridge dividing most of the factory from the neighbouring viaduct slices down the right side of the sheet, rendered as a ribbon of pale wash. The already austere forms of the industrial buildings have been starkly simplified into a series of geometric solids; the only relief from their greys and browns is provided by the clear blue of a water tank and the flat red roofs in the foreground, which seem sun-bleached.

Cement factory at L'Estaque is the one of very few of Saunders's watercolours for which a preparatory study survives; as such, it offers a valuable insight into her practice. The graphite study is on paper with a perforated left edge which suggests that it was originally part of a notebook or sketchbook, making it likely that she made the study on the spot. It appears likely that the somewhat larger watercolour would then have been worked up later in the studio; judging from the presence of multiple pinholes in the corners, this probably extended over more than one session. Interestingly, although the study is on a smaller sheet, the composition is more expansive; in the finished watercolour, the buildings appear more boxed in by the rock ridge and the compositional structure is more emphatically (or exaggeratedly) vertical. This insistent verticality seems to echo some of her earliest surviving work, such as *Litlington* (see fig. 3, p. 10).[39] It seems that her finished compositions depended on a combination of first-hand observation and later reflection away from the motif, and that this period of reflection was essential in clarifying her ideas and simplifying her vision.

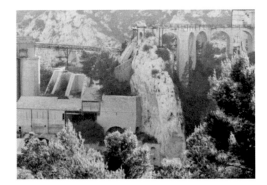

39 Lafarge cement works, L'Estaque, 1995
(photograph: David Curtis)

39 See Peppin 1996, p. 18.

83

17a

I meant just above line. Do not trim

17b

18
Viaduct at L'Estaque,
c. 1920–29

Graphite and watercolour on wove paper, with multiple pinholes at all four corners, 352 × 279 mm
Verso: inscribed *B* (upper right, graphite)
The Courtauld, London (Samuel Courtauld Trust), D.2016.XX.22

Exhibitions Oxford and Sheffield 1996, no. 32

Literature Peppin 1996, pp. 17 and 49

Not exhibited

40 Railway viaduct, L'Estaque, 1995
(photograph: David Curtis)

Despite the prominence given to it by the title, the viaduct in this watercolour appears almost as an afterthought in the background. Its span is mostly obliterated by the hulking forms of two buildings that, despite being across the road, appear directly to abut it; only parts of three arches are visible on either side. The sombre palette, dominated by pale greys and browns, draws attention to the play of overlapping, starkly simplified geometric forms of an industrial landscape that, in common with Saunders's other L'Estaque subjects, is still recognisable today.

The other artist, apart from Cézanne, associated with L'Estaque whom Saunders greatly admired was Georges Braque, and this watercolour can be seen in part as a homage to his work. By contrast to the case in cat. 16, in which she took as her subject Cézanne's house rather than a view he painted, the viaduct was the subject of two major paintings Braque produced in 1907–08 that are widely considered foundational to early Cubism.[40] However, her own composition, whilst fuelled by some of the same concerns as Braque's, takes a noticeably different approach. Where both of Braque's canvases are characterised by bright colour and brilliant light, emphasise the landscape setting of the viaduct and surrounding buildings, and show the viaduct from a relatively distant vantage point, Saunders has stripped away virtually all reference to nature in her drawing. The viewer is thrust right into the centre of the composition; only a sliver of sky is visible at the top edge of the sheet, heightening the feeling of claustrophobia. The spatial ambiguity and drive toward geometric abstraction found in Braque's work are present here, but are intertwined with Saunders's own pursuit of topographical fidelity, a thread that can be said to run through all of her surviving later landscapes.

40 On Saunders's admiration for Braque, see Brigid Peppin's essay in this volume, p. 19. The two paintings in question are *The Viaduct at L'Estaque* (1908; Paris, Centre Pompidou, inv. no. AM1984-353) and *The Viaduct at L'Estaque* (1907; Minneapolis Institute of Art, inv. no. 82.22). Saunders herself produced a second version of this subject (private collection).

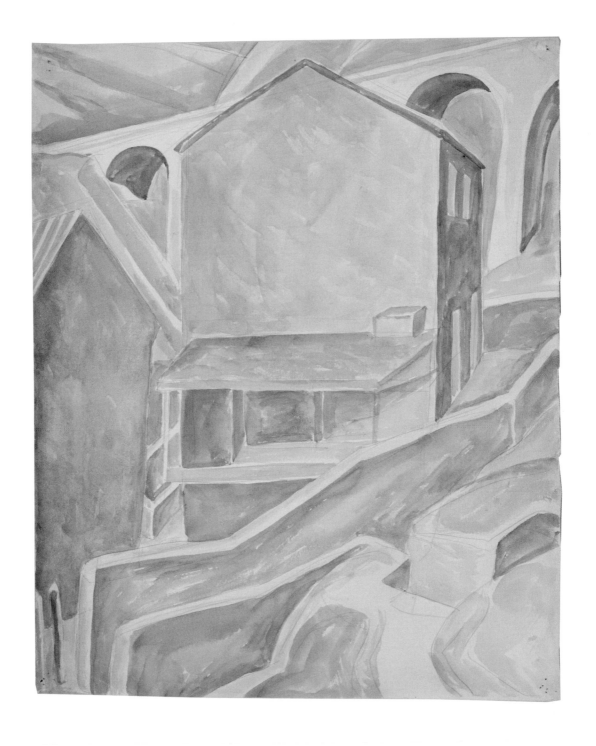

19
Wyndham Lewis
(1882–1957)
Portrait of the artist
Helen Saunders, 1913

Graphite and watercolour on laid paper,
286 × 176 mm
Watermark, upper half and recto, (C)HALLET
The Courtauld, London (Samuel Courtauld Trust),
D.2016.XX.26

Exhibitions Oxford and Sheffield 1996 (no
number)

Literature Peppin 1996, pp. 10 and 43

Not exhibited

Dressed in blue-grey and depicted half-length with her hand clasping the back of her neck, Helen Saunders appears lost in thought. Her portrait has been sketched quickly, but – to judge from the pentimenti surrounding her elbow and extending from the bridge of her nose to her chin – not without rethinking. Her hair has been formed by layering greenish-yellow watercolour over a black medium (whether graphite or watercolour is unclear), echoing the layering of colour present in some of her Vorticist compositions (see cat. 12 and 13).

Vorticism's principal – and certainly its most flamboyant – practitioner and spokesperson, Wyndham Lewis was a friend of Saunders during the most overtly radical period of her career. This portrait, which was in Saunders's possession when she died, is one of several in widely varying styles he made of her between 1912 and 1913. Judged against the handful of surviving photographs of the artist, this is an accurate if unflattering likeness. Beyond the particularities of Saunders's physical appearance, this portrait suggests the introspection and solitude that were an essential aspect of her personality, which she herself described as 'solitary by nature', and which are very much of a piece with the independence of spirit that characterised the whole of her career.

Helen Saunders: Chronology

1885 4 April: Birth of Helen Beatrice Saunders, second daughter of Alfred Saunders, a solicitor and Rating Agent for the Great Western Railway, and Annie (Paley) at 20 Addison Road, Bedford Park, Ealing. She grows up at various addresses in Ealing, and with her sister Ethel is educated at home by governesses and tutors.

1901 The family is joined by Annie's father Dr William Paley (1816–1911).

c. 1903–06 Saunders attends Rosa Waugh's teaching studio in Ealing.

1907 January–March: Saunders attends the Slade as a part-time student.

1909 Closure of Waugh's studio due to financial difficulties. Waugh starts teaching at University College Cardiff.

c. 1909–10 Saunders attends classes at the Central School of Arts and Crafts.

1911 13 March: Death of William Paley; his daughter Annie Saunders receives a substantial legacy.

17 June: Saunders participates in the 'Prisoners' Pageant' section of the WSPU's Coronation Procession.

c. 1911 Moves to rented rooms at 4 Phene Street, Chelsea.

c. 1911–12 Beginning of Saunders's friendship with Wyndham Lewis (1882–1957).

1912 February: Shows *Rocks, North Devon* at the Friday Club exhibition.

May: Exhibits in Roger Fry's exhibition 'Quelques Indépendants Anglais' at the Galerie Barbazanges in Paris.

July: *Figure composition, Portrait* and *Sketch*, shown at the Allied Artists' Association London Salon, are favourably noticed by Clive Bell and Roger Fry.

Publication of Waugh's biography of her father, NSPCC founder Benjamin Waugh.

Saunders's artist cousin Reynolds Ball (1882–1918) shares a studio with Hubert (Schloss) Waley in Queen's Mansions, near London's Caledonian Market.

1913 February: Alfred Saunders retires and the family moves to West Liss, Hampshire.

Saunders is friends with Jessica Dismorr.

15–31 March: She participates in the 1st Grafton Group exhibition at the Alpine Gallery, curated by Roger Fry, probably showing *Barn and Road*.

July: Saunders exhibits *The Oast House* at the Allied Artists' Association London Salon.

1914 Ezra Pound, in an article in *The Egoist*, proposes a College of Arts with Saunders.

April–June: Active in the Rebel Art Centre at 38 Great Ormond Street.

May–June: Shows *Rocks* (black and white) and *Portrait of a Woman* at the 'Twentieth Century Art Exhibition' at the Whitechapel Art Gallery.

2 July: Signs the Vorticist Manifesto and takes partial responsibility for distributing *BLAST*.

July: Shows *The Maid and the Magpie* at the Allied Artists' Association London Salon.

28 July: Outbreak of World War I.

Ball registers as a conscientious objector and joins a Quaker relief mission in France.

1915 May: Waugh marries Stephen Hobhouse.

June: Saunders contributes six works to the Vorticist exhibition at the Doré Galleries: *Atlantic City, English Scene, Swiss Scene* and *Cliffs* (paintings) and *Island of Laputa* and *Black and Khaki* (drawings).

July: Publication of *BLAST 2*. 4 Phene Street (spelled as 'Phené') is given as the distribution address.

Summer/Autumn: Collaborates with Wyndham Lewis on the 'Vorticist Room' at the Restaurant de la Tour Eiffel.

Attends Imagist/Vorticist dinners at Gennaro's restaurant in Soho, and meets Harriet Weaver, editor of *The Egoist* and financial backer of James Joyce and the feminist philosopher Dora Marsden.

1916 18 January: The Vorticist Room opens at the Restaurant de la Tour Eiffel. Lewis attests for army service.

March: Lewis is posted to Dover, then Weymouth, for army training.

Saunders does war work in a government office, and acts as unpaid secretary to Lewis while he is away. She writes poems but has no time to paint.

Waugh Hobhouse spends three months in Northampton Prison for refusing to pay the fine imposed on her for distributing pacifist literature.

Summer: Saunders shows *Waterloo Bridge* and *Painting* at the 4th London Group exhibition.

9 September: Ezra Pound negotiates the sale of *Canon*, *Dance* and *Balance* to John Quinn for £18 (total).

Saunders subscribes to Arthur Waley's privately published *Chinese Poems*.

1917 January: *Canon, Dance, Balance* and *Island of Laputa* are shown in the Vorticist exhibition at the Penguin Club, New York.

Summer: Lunch at Pagani's with Lewis's friend Captain Guy Baker, Ezra Pound and Dorothy Shakespeare Pound.

Turns down an offer of marriage from Hubert Waley.

June-December: Ethel Saunders serves as a VAD at the Belgian Military Hospital in Rouen.

Reynolds Ball joins a relief mission to Russia.

1918 January: Saunders's parents move to 76 Woodstock Road, Oxford.

19 June: Watches a new Charlie Chaplin film on the eve of Ethel Saunders's return to Rouen.

Early September: A week in Cornwall with her mother.

Mid-September: Attends three performances by the Ballets Russes at the Coliseum.

October: Moves to 49 Maple Street, London W1.

20 November: World War I ends.

17 December: Death of Ball in Warsaw from typhus fever while on a famine relief mission.

20 December: Ethel Saunders returns from France.

1919 Late January: Lewis contracts influenza followed by double pneumonia; Ethel Saunders secures his emergency admission to the Endsleigh Hospital for Officers.

Lewis breaks off contact with Helen Saunders, who apparently then suffers a breakdown.

1922 Saunders becomes friends with Walter Sickert.

Her parents move to 4 Rawlinson Road, Oxford.

December 1922–March 1923: Works in the *Egoist* Press office while Harriet Weaver is away.

She is drawn by Lewis.

1920s She paints at L'Estaque and Port Isaac.

1928 She types parts of Dora Marsden's manuscript *The Definition of the Godhead* for Weaver.

1930–31 Exhibits still-life paintings with the London Group as a non-member.

1933 Moves to 10 John Street, Holborn, sharing with Blanche Caudwell.

1938 Death of Alfred Saunders.

1939 29 August: Suicide of Jessica Dismorr.

1940 Saunders does war work for the London County Council.

10 John Street is badly damaged by bombing; many paintings by Saunders are lost. She moves with Caudwell to 5 Great Ormond Street.

Shows a painting at the Artists' International Association.

1941 Harriet Weaver moves to 4 Rawlinson Road as the paying guest of Annie and Ethel Saunders.

1942 Saunders joins the Artists' International Association as a professional member, subscribing until 1960.

1950 (late) Death of Blanche Caudwell.

1951 Saunders moves to 39 Gray's Inn Road.

1950s Holidays at St David's (Wales), Switzerland and northern Italy with Ethel Saunders.

1956 May: She contributes *Design for a Book Cover* to *Wyndham Lewis and Vorticism* (Tate) and visits the exhibition with Madge Pulsford.

11 November: Death of Annie Saunders.

1957 Sale of 4 Rawlinson Road.

1960 Saunders visits the Nicolas Poussin exhibition at the Louvre in Paris.

1962 September: Injures her arm in a fall

1963 1 January: Saunders dies from coal-gas poisoning at 39 Gray's Inn Road.

October: Ethel Saunders presents three Vorticist works by Saunders and a drawing by Lewis to the Tate Gallery.

1967 Ethel Saunders presents a drawing by Saunders and twelve etchings by Sickert to the Victoria and Albert Museum.

1996 Retrospective exhibition *Helen Saunders 1885–1963* held at the Ashmolean Museum, Oxford (9 January–3 March) and at the Graves Art Gallery, Sheffield (16 March–20 April).

Bibliography

Primary sources

Castner 1963
Castner, Charlotte, letter to Rosa Waugh Hobhouse, 13 January 1963 (private collection)

Dismorr 1915
Dismorr, Jessica, 'June Night', *BLAST, War Number,* ed. by Wyndham Lewis (London: John Lane, The Bodley Head, 1915), pp. 67–68

Gaudier-Brzeska 1914
Gaudier-Brzeska, Henri, 'Allied Artists' Association Ltd, Holland Park Hall', *The Egoist,* 15 June 1914, p. 228

Gliddon n.d.
Gliddon, Katie, letter to Rosa Waugh, n.d. (LSE Women's Library)

Godfrey 1995
Godfrey, Lettice, letter to Brigid Peppin, 10 March 1995 (private collection)

Kelly 2021
Kelly, Dennis, letter to Brigid Peppin, 13 September 2021 (private collection)

Lewis 1914
BLAST, No. 1, ed. by Wyndham Lewis (London: John Lane, The Bodley Head, 1914)

Lewis 1915
BLAST, War Number, ed. by Wyndham Lewis (London: John Lane, The Bodley Head, 1915)

Lewis 1956
Wyndham Lewis and Vorticism (London: Tate Gallery, 1956)

Littlewood 1995
Littlewood, Julie, letter to Brigid Peppin, 10 March 1995 (private collection)

Saunders 1917
Saunders, Helen, letter to Jessica Dismorr, November/December 1917 (collection of Quentin Stevenson)

Saunders 1918
Saunders, Ethel, letter to her mother, Annie Saunders, 1918 (private collection)

Saunders 1956
Saunders, Helen, letter to Martin Butlin, 9 May 1995 (Tate Archives)

Saunders 1962a
Saunders, Helen, letter to William Wees, 1 September 1962 (collection of William Wees)

Saunders 1962b
Saunders, Helen, letter to Walter Michel, 2 September 1962 (Wyndham Lewis Memorial Trust)

Saunders 1962c
Saunders, Helen, letter to Walter Michel, 27 October 1962 (Wyndham Lewis Memorial Trust)

Saunders 1962d
Saunders, Helen, typed transcript by Rosa Waugh Hobhouse of 'Helen's last letter to me', dated 19.XII.62 (private collection)

Waugh 1908
Waugh, Rosa, *The Science of Natural Perspective,* typed transcript, 1958, of 1908 manuscript (private collection)

Music Hall and Theatre Review, 27 June 1912, p. 11

'The Cabaret Club', *Pall Mall Gazette,* 29 September 1913, p. 13

'The Vorticists. Perils of a West End Restaurant', *Pall Mall Gazette,* 15 January 1916, p. 3

Photograph, *Daily Mirror,* 18 January 1916, p. 2

'Mr. Wyndham Lewis Enlists', *Daily Mirror,* Friday 25 February 1916, p. 10

'Preliminary Announcement of the College of Arts', *The Egoist,* 2 November 1924, pp. 413–14

R. De Cordova, 'Thumbnail Interviews With The Great', *The Sphere,* 12 June 1926, pp. 277–79

'The Round of the Day', *Westminster Gazette,* Friday 17 September 1926, p. 8

'The Passing Pageant 1910–1920', *The Tatler,* 1 May 1935, pp. 32–33

'London's "Eiffel Tower"', *Lancashire Evening Post,* Saturday 7 August 1937, p. 4

Belfast Telegraph, 10 August 1937, p. 6

Secondary sources

Antliff 2010
Antliff, Mark, 'Alvin Langdon Coburn among the Vorticists', *The Burlington Magazine,* vol. 152, no. 1290, 2010, pp. 580–89

Bazin 1964
Bazin, Germain, *Baroque and Rococo,* London, 1964

Beckett and Cherry 1988
Beckett, Jane, and Deborah Cherry, 'Women under the Banner of Vorticism', *ICSAC Cahiers 8/9,* Brussels, 1988

Beckett and Cherry 1998
Beckett, Jane, and Deborah Cherry, 'Modern women, modern spaces: women, metropolitan culture and Vorticism', in *Women Artists and Modernism,* ed. by Katy Deepwell, Manchester, 1998

Beckett and Cherry 2000
Beckett, Jane, and Deborah Cherry, 'Reconceptualizing Vorticism: Women, Modernity, Modernism', in *BLAST, Vorticism 1914–18,* ed. by Paul Edwards, Aldershot and Burlington, 2000, pp. 59–72

Beckett 2001
Beckett, Jane, '(Is)land narratives: Englishness, visuality and vanguard culture 1914–1918', in *English art 1860–1914. Modern artists and identity,* ed. by David Peters Corbett and Lara Perry, New Brunswick, New Jersey, 2001, pp. 195–212

Bell 1914
Bell, Clive, *Art,* London, 1914

Blunt 1953
Blunt, Anthony, *Art and Architecture in France, 1500–1700,* Harmondsworth, 1953

Brooker 2007
Brooker, Peter, *Bohemia in London. The Social Scene of Early Modernism,* Basingstoke and New York, 2007

Carpenter 1998
Carpenter, Humphrey, *A Serious Character, The Life of Ezra Pound,* New York, 1988

Chamot, Farr and Butlin 1964
Chamot, Mary, Dennis Farr and Martin Butlin, *Tate Gallery, The modern British paintings, drawings and sculpture,* vol. 2, London, 1964

Chipkin and Kohn 2020
Chipkin, Rebecca, and Helen Kohn, 'Beneath Wyndham Lewis's Praxitella, The Rediscovery of a lost Vorticist work by Helen Saunders', https://courtauld.ac.uk/wp-content/uploads/2021/04/July2020_Final-Report_Chipkin_Kohn.pdf

Cork 1974
Cork, Richard, *Vorticism and its Allies,* London, 1974

Cork 1975
Cork, Richard, *Vorticism and Abstract Art in the First Machine Age,* vol. 1, London and Bedford, 1975

Cork 1976
Cork, Richard, *Vorticism and Abstract Art in the First Machine Age,* vol. 2, London and Bedford, 1976

Cork 1985
Cork, Richard, *Art Beyond the Gallery in Early 20th Century England,* New Haven and London, 1985

Cottrell 2019
Cottrell, Jo, 'Bohemia in London: Frida Strindberg's Cabaret Theatre Club', in *Into the Night. Cabarets and Clubs in Modern Art,* ed. by Florence Ostende with Lotte Johnson, London, 2019, pp. 86–101

David 1988
David, Hugh, *The Fitzrovians, A Portrait of Bohemian Society 1900–55,* London, 1988

Deepwell 2015
Deepwell, Katy, 'Narratives of Women Artists in/out of Vorticism', in *International Yearbook of Futurism Studies, Volume 5,* ed. by Gunter Berghaus, Berlin and Boston, 2015, pp. 21–43

Dickson 2005
Dickson, Malcolm, *Etchells 1886–1973,* dissertation, Architectural Association, London, 2005

Edwards 1994
Edwards, Paul, 'What Were Red Duet?', *Wyndham Lewis Annual,* 1994, pp. 34–8

Edwards 2000a
BLAST: Vorticism 1914–18, ed. by Paul Edwards, Aldershot and Burlington, 2000

Edwards 2000b
Edwards, Paul, *Wyndham Lewis, Painter and Writer,* New Haven and London, 2000

Edwards 2008
Edwards, Paul, 'Foreword', *BLAST,* No. 1, ed. by Wyndham Lewis, London, 2008, pp. v–xii

Foster 2019
Foster, Alicia, *Radical Women: Jessica Dismorr and her Contemporaries,* exh. cat., Pallant House Gallery, Chichester, 2019

Garnett 1955
Garnett, David, *Flowers of the Forest,* London, 1955

Goldring 1943
Goldring, Douglas, *South Lodge, Reminiscences of Violet Hunt, Ford Madox Ford and the English Review Circle,* London, 1943

Goldschneider 1938
Goldschneider, Ludwig (introduction), *El Greco,* London, 1938

Gruetzner Robins 1997
Gruetzner Robins, Anna, *Modern Art in Britain 1910–1914,* London, 1997

Gruetzner Robins 2011
Gruetzner Robins, Anna, 'Reforming with a Pick-Axe': The First Vorticist Exhibition at the Doré Galleries in 1915', in *The Vorticists,* ed. by Mark Antliff and Vivien Green, London, 2011, pp. 59–65

Gruetzner Robins 2014
Gruetzner Robins, Anna, 'The Company of Strangers', in *Max Weber: An American Cubist in Paris and London, 1905–15,* ed. by Sarah MacDougall, London 2014, pp. 58–105

Harrison 1981
Harrison, Charles, *English Art and Modernism 1900–1939,* London and Bloomington, 1981

Heathcock 1999
Heathcock, Catherine, 'Jessica Dismorr (1885–1939): Artist, Writer, Vorticist', unpublished doctoral thesis, University of Birmingham, 1999

Hickman 2013
Hickman, Miranda, 'The Gender of Vorticism: Jessie Dismorr, Helen Saunders, and Vorticist Feminism' in *Vorticism: New Perspectives,* ed. by Mark Antliff and Scott W. Klein, Oxford, 2013, pp. 119–36

Hickman 2015
Hickman, Miranda, 'Beyond the Frame: Reassessing Jessie Dismorr and Helen Saunders', *International Yearbook of Futurism Studies, Volume 5,* ed. by Günter Berghaus, Berlin and Boston, 2015, pp. 44–69

Lewis 1919
Lewis, Wyndham, *The Caliph's Design,* London, 1919

Lewis 1950
Lewis, Wyndham, *Rude Assignment,* London, 1950

Lidderdale and Nicholson 1970
Lidderdale, Jane, and Mary Nicholson, *Dear Miss Weaver: Harriet Shaw Weaver 1876–1961,* London, 1970

Lipke 1996
Lipke, William C., *A History and Analysis of Vorticism,* Madison, WI, 1996

Marinetti 1909
Marinetti, Filippo Tommaso, 'Declaration of Futurism', *Poesia,* vol. 5, no. 6, April 1909, p. 1

Michel 1971
Michel, Walter, *Wyndham Lewis, Paintings and Drawings,* London, 1971

Munton 2006
Munton, Alan, 'Abstraction, Archaism and the Future: T.E. Hulme, Jacob Epstein and Wyndham Lewis', in *T.E. Hulme and the Question of Modernism,* ed. Andrzej Gasiorek and Edward P. Comentale, Aldershot and Burlington, 2006, pp. 74–92

O'Keeffe 2000
O'Keeffe, Paul, *Some Sort of Genius, A Life of Wyndham Lewis,* London, 2000

Peppin 1996
Brigid Peppin, *Helen Saunders (1885–1963),* introduction by Richard Cork, exh. cat., Oxford, Ashmolean Museum, and Sheffield, Graves Art Gallery, 1996

Peppin 2010
Brigid Peppin, 'The Thyssen *Vorticist composition*: a new attribution', *The Burlington Magazine,* vol. 152, no. 1290 (September 2010), pp. 590–94

Schiff 1984
Schiff, Richard, *Cézanne and the End of Impressionism,* Chicago and London, 1984

Slocombe 2017
Slocombe, Richard, *Wyndham Lewis: Life, Art, War,* London, 2017

Spalding 1980
Spalding, Frances, *Roger Fry, Art and Life,* St Albans, 1980

Stevenson 1974
Stevenson, Quentin, *Jessica Dismorr 1885–1939*, London, 1974

Stevenson 2000
Stevenson, Quentin, *Jessica Dismorr & Catherine Giles*, London, 2000

Swift 1735
Swift, Jonathan, *The Travels into Several Remote Nations of the World by Captain & Doctor Lemuel Gulliver, 1st a Surgeon and then a Captain of Several Ships (Gulliver's Travels)*, London, 1735

Thomas 1994
Thomas, Alison, *Portraits of Women: Gwen John and Her Forgotten Contemporaries*, Cambridge 1994

Tickner 1992
Lisa Tickner, 'Men's Work? Masculinity and Modernism', *differences: A Journal of Feminist Cultural Studies*, vol. 4, no. 3, 1992, pp. 1–37

Tickner 1994
Tickner, Lisa, 'Men's Work? Masculinity and Modernism', in *Visual Culture. Images and Interpretations*, ed. by Norman Bryson, Michael Ann Holly and Keith Moxey, Middletown, CT, 1994, pp. 42–82

Tickner 2000
Tickner, Lisa, *Modern Life and Modern Subjects: British Art in the Early 20th Century*, New Haven, 2000

Wadsworth 1914
Wadsworth, Edward, 'Inner Necessity', *BLAST 1*, London, 1914, pp. 119–25

Warren
Warren, Richard, 'Helen Saunders, a Little Gallery', https://richardawarren.wordpress.com/helen-saunders-a-little-gallery

Waugh Hobhouse, 1957
Waugh Hobhouse, Rosa, *An Interplay of Life and Art*, Broxbourne, 1957

Wees 1972
Wees, William, *Vorticism and the English Avant-Garde*, Toronto, 1972

Wilson 2000
Wilson, Andrew, 'Rebels and Vorticists: "Our little Gang"', in *BLAST, Vorticism, 1914–18,* edited by Paul Edwards, London, 2000

Exhibitions

London 1915
Vorticist exhibition, Doré Galleries, London, 1915

London 1974
Vorticism and its Allies, Hayward Gallery, London 1974

Oxford and Sheffield 1996
Helen Saunders, 1885–1963, Ashmolean Museum, Oxford, and Graves Art Gallery, Sheffield, 1996

Hanover and Munich 1996
BLAST, Sprengel Museum, Hanover, and Haus der Kunst, Munich, 1996–97

London 1997
Modern Art in Britain 1910–1914, Barbican Art Gallery, London, 1997

Wolfsburg and Toulouse 2003
Blast to Freeze, Kunstmuseum, Wolfsburg, and Les Abattoirs, Toulouse, 2003

London and Manchester 2004
Blasting the future, Estorick Collection of Modern Italian Art, London, and Whitworth Art Gallery, Manchester, 2004

Durham, Venice and London 2010
The Vorticists. Manifesto for a Modern World, Nasher Museum of Art at Duke University, Durham, North Carolina; Peggy Guggenheim Collection, Venice, and Tate Britain, London, 2010

London 2014
Max Weber: an American cubist in Paris and London, 1905–15, Ben Uri Gallery, London, 2014

Cambridge 2015
New Rhythms: Henri Gaudier-Brzeska, Kettle's Yard, Cambridge, 2015

London 2017
CORPUS: The Body Unbound, The Courtauld Gallery, London, 2017

Chichester 2019
Radical Women: Jessica Dismorr and her Contemporaries, Pallant House Gallery, Chichester, 2019

Preston 2020
The Artful Line: Drawings from the Harris collection and The Courtauld Gallery, The Harris Museum and Art Gallery, Preston, 2020

London 2021
Pen to Brush: British Drawings and Watercolours, The Courtauld Gallery, London, 2021

Paris 2021
Women in Abstraction, Centre Pompidou, Paris, 2021

Photographic credits

- before interested in *uvres & nature* ⟹ city vs vortisum
⤷ counterpoint vs
pier #2

Some just on HB
⤷ Cottell
- exhibition catalog

Most few warm & clear do you see it

⟹ get the identity & recognition —①- We write at publicity - behind room
⤷ use the log

3 diff works - say rep - does she use to
be something romat of body
warm